TWO HUNDRED YEARS OF
AMERICAN ART

TWO HUNDRED YEARS OF
AMERICAN ART

THE MUNSON-WILLIAMS-PROCTOR INSTITUTE

Essays by
Wayne Craven
and
Richard Martin

Organized by The Art Museum Association of America

*This catalogue was made possible by a generous grant
from the PepsiCo Foundation*

*Distributed by the
University of Washington Press
Seattle and London*

Exhibition Tour
Montgomery Museum of Fine Arts
Montgomery, Alabama
November 15, 1986–January 10, 1987

The R. W. Norton Art Gallery
Shreveport, Louisiana
January 21–March 18, 1987

Tucson Museum of Art
Tucson, Arizona
March 28–June 7, 1987

Sunrise Museums
Charleston, West Virginia
June 19–August 7, 1987

Bass Museum of Art
Miami Beach, Florida
September 19–November 14, 1987

San Antonio Museum of Art
San Antonio, Texas
December 19, 1987–February 13, 1988

Oklahoma Museum of Art
Oklahoma City, Oklahoma
March 12–May 7, 1988

The publication of this catalogue was aided by
a generous grant from the PepsiCo Foundation.

Editor: James Liljenwall
Photograper: Gale R. Farley
Design and production:
 Ed Marquand Book Design
Typesetting: The Type Gallery
Printing: Dai Nippon Printing Co., Ltd.

Library of Congress Catalogue Card Number 86-72031
ISBN 295–96457–X

Front Cover: Gilbert Stuart, *General Peter Gansevoort* (cat. no. 3)
Back Cover: Morgan Russell, *Synchromie Cosmique* (cat. no. 43)

Dimensions are in inches; height precedes width.

Printed in Japan

Acknowledgments

The Museum of Art, Munson-Williams-Proctor Institute in Utica, New York, is among the most important, little-known collections of American painting in this country. Particularly rich in twentieth-century work by such modernists as Morgan Russell, Charles Demuth, Marsden Hartley, Arthur Dove, Ralston Crawford, and Georgia O'Keeffe, the collection also has great strengths in late eighteenth-century portraiture and nineteenth-century still life, landscape, and genre. Long-recognized by scholars and historians of American art for its extraordinary importance, the collection is not widely known to the general public. Among the goals of this exhibition is the desire to better acquaint the American public with this hidden resource.

Also because of the historic breadth of the collection, this exhibition serves as a survey of American art over a two-hundred-year period from John Singleton Copley's *Thomas Aston Coffin* of ca. 1758 to Malcolm Morley's *Kodak* of 1971.

The exhibition has evolved as a close collaboration between the Museum of Art, Munson-Williams-Proctor Institute and The Art Museum Association of America. We at the Association are truly delighted to be able to help the Museum of Art share part of its significant collection with other institutions throughout this country. On behalf of the museums on the tour, I would like to thank the Munson-Williams-Proctor Institute for its generosity in making this collection available for tour.

I would particularly like to thank Paul J. Farinella, President; Paul D. Schweizer, Director; Sarah Clark-Langager, former Curator; and Patricia Serafini, Registrar, for their involvement in and commitment to this exhibition. It has been a great joy working with them on all aspects of the project.

At The Art Museum Association of America, Pauline Facciano, Exhibition Program Assistant, has coordinated the production of the catalogue, and Beth Goldberg, Registrar, has arranged all the technical details in preparing the exhibition for travel and will continue to monitor and supervise the exhibition over its two-year tour.

I would also like to thank the PepsiCo Foundation, whose generous support has helped make this catalogue possible.

Finally, we hope that *Two Hundred Years of American Art: The Munson-Williams-Proctor Institute* will enhance the public's understanding and enjoyment of American art. We are delighted that, through our collaborative efforts, the resources and collections of this fine American museum will be shared by a greater number of people.

Myrna Smoot
Executive Director
The Art Museum Association of America

Harold B. Nelson
Exhibition Program Director
The Art Museum Association of America

Foreword

The Munson-Williams-Proctor Institute is the legacy of three successive Utica, New York, families and is today defined by an art school, a performing arts program, and a museum. When the Institute was founded in 1919, the works of art that had been acquired by the Williams and Proctor families during the late nineteenth and early twentieth centuries became the nucleus of the permanent collection.

During the second quarter of this century, the collection did not grow, but this situation dramatically changed in the early 1950s when the Institute began a concerted effort to acquire the best paintings available. The success of this effort is apparent in the fact that during this decade more than twenty of the paintings included in this exhibition were purchased, and fifteen others were given by Edward Root, an astute collector of twentieth-century American art. Also during the 1950s, plans for a new building were initiated; a dream that was realized in 1960 when the Institute dedicated its new Museum of Art, the first such building designed by architect Philip Johnson.

There are two reasons why we have decided to put eighty-two of our best American paintings on tour. Foremost is a desire on the part of the Institute's Board of Trustees to share a representative segment of our American collection with museum audiences in parts of the United States where there is a good likelihood that the pictures are not well known.

This is the first and more than likely only time that such a large cross section of our collection of American paintings will tour the nation, and we are delighted that they will be seen and enjoyed in the seven cities of Montgomery, Alabama; Shreveport, Louisiana; Tucson, Arizona; Charleston, West Virginia; Miami Beach, Florida; San Antonio, Texas; and Oklahoma City, Oklahoma. Additionally, all the funds earned from this undertaking have been earmarked to support the publication of a comprehensive handbook of the collection—one of our long-standing needs—which has been in preparation for a number of years. When published, this checklist will serve as the companion to an interpretive volume, also in preparation, which will analyze in depth our most important American paintings.

From the time this exhibition was conceived several years ago, we have enjoyed the keen interest and enthusiastic support of several individuals at The Art Museum Association of America; the collaborative services they have provided have been exemplary. Foremost among these individuals is Harold B. Nelson, Exhibition Program Director, who coordinated this project from the start. We are also grateful to Myrna Smoot, Executive Director at The Art Museum Association, and to Lynn Upchurch, former Executive Director, for their support and administrative supervision. Through their efforts, corporate support for this project was secured from the PepsiCo Foundation. This support permitted the entire catalogue to be printed in color and allowed us to invite two distinguished scholars of American painting—Wayne Craven, H. F. du Pont Winterthur Professor of Art History at the University of Delaware, and Richard Martin, Editor and Publisher of *Arts Magazine* and Executive Director of the Shirley Goodman Resource Center at the Fashion Institute of Technology—to write interpretive essays about the works included in the exhibition. Additional funding was provided by two federal agencies, the National Endowment for the Arts and the Institute of Museum Services, which enabled us to send several paintings included in this exhibition to the Williamstown Regional Art Conservation Laboratory for cleaning and stabilization.

Paul D. Schweizer
Director
Museum of Art
Munson-Williams-Proctor Institute

Visions of America: The Eighteenth and Nineteenth Centuries

The collection of the Munson-Williams-Proctor Institute is rich not only in quality but in the breadth with which it surveys American painting, from the eighteenth century to the modern era. In addition to offering us aesthetic enjoyment, the collection allows us to explore values, ambitions, social structure, cultural growth, and intellectual interests through several phases of America's history. The portraits mirror what the people thought of themselves, while the landscapes reflect what they thought of the land, how it was to be used, and related moral, poetic, economic, and political questions. America's love affair with nature is expressed and nature's abundance is depicted in the still lifes, while genre scenes celebrate or otherwise comment upon everyday life in America.

The collection shows, however, that as the nineteenth century waned Americans became self-conscious and looked increasingly to Europe for social, cultural, and artistic guidance. Moreover, their economic power, as new as it was vast, enabled them to play the role of grand patron on an international scale. Turning away from the native-born artists, the native vocabulary of artistic expression, and the truly American subjects that had given uniqueness and distinctiveness to earlier nineteenth-century American painting, Americans sought the proven, venerable mantle of Old World culture that collections of Old Masters bestowed. This phase in turn gave way to the rise of the modern movement, as we will see in the essay that follows this one.

The Colonial era is beautifully represented in the Institute's collection. *Thomas Aston Coffin,* ca. 1758 (cat. no. 1), by John Singleton Copley, was painted when the artist was only twenty and almost totally self-taught. Portraiture was virtually the only subject of Colonial painters, whose purpose was to convey the prosperity, refinement, and social position of the subject—or, in this case, the subject's family. Little Thomas's father was William Coffin, a successful Boston merchant who could be expected to appreciate Copley's ability to capture such material expressions of affluence as the fine fabrics and handsome garments in this work. It was usual in painting an image of a child to include pets and playthings, and so the artist had young master Thomas hold a ribbon tethering two pet pigeons, while a shuttlecock and battledore lie at his feet. The affectionate relationship of a child and his mother is tenderly expressed in the portrait *Mrs. James Watson and Son James Talcott,* 1788 (cat. no. 2), by Ralph Earl. Although Earl studied for several years in England, after his return to America in 1785 he continued to work in an essentially Colonial style, which his patrons along the Connecticut Valley found completely satisfactory.

The style of portraiture in most areas of the new nation changed significantly after Gilbert Stuart returned to New York in 1793, after eighteen years in London and Dublin, bringing with him the late eighteenth-century English type of portrait that had been established by Sir Joshua Reynolds, Thomas Gainsborough, and George Romney. His *General Peter Gansevoort,* ca. 1794 (cat. no. 3), possesses a sophisticated elegance and painterly virtuosity that swept aside the provincialisms of the Colonial style. Stuart also worked in Philadelphia and in the newly created national capital of Washington before settling in Boston in 1805, spreading his new style of fluid brushwork everywhere he went. His influence is seen, for example, in the portrait *Mrs. John Leake Norton* (cat. no. 5), painted about 1815 by John Wesley Jarvis, who became the leading portrait painter in New York City in the first two decades of the nineteenth century. The reserved dignity of portraits by Stuart, Jarvis, and others worked perfectly with the neoclassical Federal interiors into which they were being placed.

To some, however, the vision of a great new nation called for an art of greater ambition than the mere painting of likenesses. Since the seventeenth century, history painting had been considered by

I

many the highest form of art because it offered the greatest challenge to the artist and the greatest lessons in morality, religion, nationalism, and enlightenment to the viewer.

Among history painters, Benjamin West, an American from Lancaster, Pennsylvania, had become the recognized master in London during his long career there from 1763 to 1820. Other young American painters—such as John Trumbull and Washington Allston—had followed West's lead; they tried to implant this aesthetic in the United States as a way of showing that America was the ascending cultural center of the Western world. Enormous canvases showing heroic, tragic, or miraculous events from the Bible, Shakespeare, ancient and modern history, or classical mythology now set the standard by which the greatness of art was judged.

The representative from this school in the Institute's collection is Joshua Shaw's *Morning, Distant View of Carthage—Dido and Aeneas Going to the Hunt* (cat. no. 10), painted about 1831. The story, set in a landscape that is Claudian and Turneresque, illustrates a scene from Book IV of Virgil's *Aeneid*. Dido, Queen of Carthage, falls in love with Aeneas, shipwrecked upon her shore after fleeing the ruined Troy. They ride off together on a hunt (they are seen on horseback in the lower right), and when an approaching storm forces them to take cover in a cave, their passion is consummated. The statue of Cupid and Psyche at the left refers to their love affair. Shaw, an English-born sign painter and self-taught artist who came to America in 1817, was better at landscape than he was at figure painting, and he more frequently painted pleasant views of local scenery.

American patrons, however, soon made it clear they did not want paintings of this type, insisting instead upon subjects with which they could identify, such as the American land and home life, painted in a style that they could appreciate—one based on a direct observation of nature rather than on European Renaissance or Baroque art or on theory. America was asserting its independence in matters of art just as it was awakening to many other aspects of its unique culture.

Paintings of the American landscape captured the romantic, poetic, and nationalistic spirit of Americans beginning about 1825. But even earlier, about 1793, English-born William Winstanley had come to America to paint lyrical views of beautiful scenery, such as *The Meeting of the Potomac and Shenandoah Waters at Harper's Ferry,* 1795 (cat. no. 4). George Washington enjoyed Winstanley's work so much that he bought four landscapes for his home, Mt. Vernon, where they may still be seen.

It was in the hands of American-born artists that the great flowering of landscape painting occurred. True, the so-called Hudson River School was launched in 1825 by Thomas Cole, an English-born immigrant who actually preferred to paint great multi-canvas fantasies and moral tableaux, often incorporating the ruins of antiquity that still dotted the European landscape.

Many American painters followed his lead, as we see in *Castle by the Lake,* 1855 (cat. no. 15), by Jasper Cropsey, a medieval English scene as painted by a visiting American artist, and in *Galleries of the Stelvio, Lake Como,* 1878 (cat. no. 28), by Sanford R. Gifford, executed from sketches he made as he toured Italy. But while landscapes of this sort carried an aura of exoticism and Old World charm, most Americans of mid-century favored simple or dramatic visions of their own land.

Pictures like *Trout Fishing in Sullivan County, New York,* ca. 1841 (cat. no. 12), by Henry Inman, show the pleasures that a mountain stream provides for three men on an outing in nature, surrounded by poetically interpreted scenery. Life in the great outdoors was a special theme for painters, like Arthur Fitzwilliam Tait, as we see in his *Mink Trapping in Northern New York,* 1862 (cat. no. 20). The outdoorsman theme was sometimes combined with a view of some celebrated natural phenomenon, as when Ferdinand Richardt, a Danish-born artist who came to America about 1856, painted *Trenton Falls,* 1858 (cat. no. 17). Three fishermen in the foreground are dwarfed by the beautiful, thundering, terraced waterfall behind. On a ridge at the upper left, other figures gaze pensively on the grand display.

Excursions into undisturbed wilderness were seen as antidotes to the social evils and woes that beset civilization with the intensification of the Industrial Revolution. Landscape paintings, it was believed, could serve as surrogates for such experiences; at the end of a long, hard day, a businessman, banker, or mill owner could retire to his library to contemplate such a painting for its restorative, therapeutic, and spiritual effect. The American wilderness was seen as a new Eden that God had kept in reserve, and His presence was to be discovered in the natural wonders of sunsets, mountain ranges, great forests, and secluded nooks in the woods. Frederic Church painted just such a picture in *Sunset*, 1856 (cat. no. 16), where the glory of God, as seen in His undefiled creation, is the perfect remedy to a soul world-weary from the hustle and bustle of the factory, the miseries of the mills, or the slums of the cities. Naturalism was the foundation of the style according to which such scenes were painted, but it was a naturalism that incorporated a romantic, poetic, and spiritual vision as well. In Church's picture, a few gentle sheep—domesticated creatures—imply the unseen presence of man, but in David Johnson's *Brook Study at Warwick*, 1873 (cat. no. 26), the viewer is the only human presence, and the intimate scene provides a solitude in which one may commune with God.

Seashores, too, with their unending expanses of ocean and their magnificent sunrises and sunsets, could suggest God's presence in nature, as in Francis A. Silva's *Sunrise: Marine View*, ca. 1870 (cat. no. 25), where the silence of the scene is disturbed only by a gently breaking wave. Silva emphasizes man's isolation by including a remote lighthouse, while William Trost Richards emphasizes the endless horizon by adding diminutive sailing ships in *Summer Clouds*, 1883 (cat. no. 31). The theme in each of these seascapes is the peacefulness of nature. But the ocean can also display terrifying wrath, and its thundering swells can send sailing ships crashing upon the shore. Edward Moran sensed the drama of such events, which occurred frequently in the nineteenth century, and in his *Shipwreck*, 1862 (cat. no. 19), portrays man's pathetic struggle in the face of nature's awesome power. The nineteenth-century observer of such pictures would see them not only as views of nature but would also, in good romantic fashion, see them as symbols—in these cases, of the glory of God in a sunrise, the peace of God in a tranquil sea, the wrath of God in a violent storm, and the humbleness of man as he confronts the grandeur of God's creation.

Mid-nineteenth-century Americans also enjoyed pictures that illustrated their favorite literature, for the nation now had its own school of authors led by men of international reputation such as Washington Irving and James Fenimore Cooper. John Quidor's *Anthony Van Corlear Brought into the Presence of Peter Stuyvesant*, 1839 (cat. no. 11), is based on a scene from Irving's *A History of New York . . . by Diedrich Knickerbocker*, which achieved great popular acclaim after it was published in 1809. In Book V, Chapter II, after Governor Peter Stuyvesant has arrived in New Amsterdam, the comic, rotund "champion and garrison" of the colony, Anthony Van Corlear, is escorted into his presence; when asked by the governor how he has come to be such an honored person, Anthony replies, "like many a great man before me, simply by sounding my own trumpet"—and at that moment this little man of "immeasurable wind" gives a clangorous blast on the instrument that shatters the calm for miles around. Quidor, sensitive to the wry wit of Irving's tale, presents the scene as a farce or even a burlesque. Of a quieter and more melodramatic mood is William Edward West's *Annette de l'Arbre*, 1831 (cat. no. 9), painted while this American artist was working in England. Taken from Irving's *Bracebridge Hall* (1822), it depicts young Annette being prepared, by the village doctor and other friends, for the shock of seeing again her beloved Eugene (peering from behind a tree), who she believes had been lost at sea.

Homey genre scenes, too, appealed to the mid-nineteenth-century American patron, and in response the painters have left us a marvelous visual record of the life of ordinary folk. Genre painting arose in the United States about the same time that common persons began to assert themselves as an electorate body and as an economic force in the 1830s. America was, after all, a nation of the common people, so what more fitting subject could an artist have than everyday

events of life in the vernacular? Responsibility to be informed was concomitant with the right to vote, and genre paintings often took up such scenes as we see in James G. Clonney's *Mexican News*, 1847 (cat. no. 13), which shows two local residents on the front porch of an inn or tavern discussing the hottest news item of the day, the impending war with Mexico over territorial claims to Texas. The chest-thumping bravura of an America in an expansionist mood is but thinly veiled here; the idea of Manifest Destiny and the right of the United States to expand westward to the Pacific Ocean was formulated during this period.

Hop Picking, 1863 (cat. no. 22), by Tompkins Matteson celebrates the hard-working farmer and the wonderful abundance of the American land. Set in upstate New York, the scene depicts the wholesomeness of working the land and the fruitful rewards of harvest time. Golden idylls like this were, for mid-century America, a realization of the American dream.

A few painters, however, directed their vision toward the social problems developing in the cities as a result of increasing urbanization and the Industrial Revolution. David Gilmour Blythe's *Washday*, ca. 1858 (cat. no. 18), is a haunting condemnation of the pathetic conditions of the poor who lived in urban slums. While Blythe painted in a style that borders on caricature, Eastman Johnson was a more detached observer of the social plight of blacks, as in *The Chimney Corner* (cat. no. 21), painted in 1863, the year of Lincoln's Emancipation Proclamation and the Battle of Gettysburg. Johnson's somber palette is appropriate to the hard life and grey existence of his aged subject with gnarled hands and cane. We are moved by the man's struggle to read, a right denied to his class since slavery began. John George Brown finds the poor newsboys or bootblacks of New York City to be romantic subjects equal to Murillo's street urchins of Seville or Madrid. His *Boot-black with Rose*, 1878, (cat. no. 27), shows a Horatio Alger-type shoeshine boy admiring a rose, with which he attempts to decorate his grimy, tattered attire.

If deprivation plagued the United States in the nineteenth century, America was also the land of abundance, and nowhere was that expressed more clearly than in the still life paintings that began to appear after 1815. Several members of the Peale family of Philadelphia were among the earliest practitioners of this sort of painting. They are represented in the exhibition by James Peale and his nephew Raphaelle Peale. Their *Still Life—Apples, Grapes, Pear*, 1824–26 (cat. no. 7), and *Still Life with Steak*, ca. 1817 (cat. no. 6), prefigure the fuller treatment of the abundance theme that culminates in the magnificent mid-century fruit, flower, and vegetable pieces by Severin Roesen, whose *Still Life with Fruit and Champagne* (cat. no. 14) was painted in 1853, five years after the artist emigrated from Germany, where he had been a porcelain painter. There is a sensual feeling of ripeness, of fruition, of the wonderful plenitude of harvest time that permeates the image, and it is made all the more zestful by the inviting glass of bubbly champagne at the lower left. The work is a joyous visual hymn to the fecundity of the American land.

The naturalism with which Roesen worked is intensified into trompe l'oeil in the art of such later nineteenth-century still life painters as William Harnett and John F. Peto. Trompe l'oeil (trick of the eye) is the creation of a visual image of such realism that it vies with the reality of actual objects in the real world. Realism was one of the most powerful movements in late nineteenth-century American painting, with Thomas Eakins its foremost exponent. Both Harnett and Peto studied at the Pennsylvania Academy of the Fine Arts, where Eakins taught. But the subjects and styles of their works differ from Eakins's, and pictures like Harnett's *A Study Table*, 1882 (cat. no. 30), and Peto's *Fishhouse Door with Eel Basket*, ca. 1890 (cat. no. 33), tend to tell stories by means of the objects they include. These stories are sometimes political, sometimes biographical, and at other times something else, often with a haunting melancholy about them.

Nineteenth-century America was undergoing changes that were often cataclysmic. So it is not surprising that dramatic changes occurred in painting, and nowhere were these effects more apparent than in portraiture. Charles Loring Elliott, for example, one of the leading portrait painters of the mid-century, departed from the suave elegance of Federalist portraiture to introduce a realism

that attempted to compete with the photographic image, which was all the rage after its introduction into America in 1839. But when painting the likeness of an attractive young woman, as in his *Cornelia Perkins,* 1864–65 (cat. no. 23), he would often temper the realism with qualities his Victorian contemporaries respected or enjoyed—qualities such as innocence, melancholy, or romantic reverie.

Later in the century, however, William Merritt Chase would paint a very different image of womanhood and reveal very different influences—as in his *Memories,* 1885–86 (cat. no. 32). After the Civil War, America seems to have lost her preoccupation with the innocence and delicacy of womanhood, and in a painting like Chase's such moral concerns are not at issue. As a reaction to Realism, many painters, Chase included, sought an art based on rich, painterly qualities, exciting brushwork, and styles learned from travel and study in Europe. His *Memories* reveals a range of contemporary influences from Sargent's slashing brushstroke, to Whistler's cool tonal symphonies, to the spontaneity of French Impressionism.

Mid-century America was so full of herself that she only wanted pictures of purely American subjects, painted in a style that grew out of her respect for nature and her pragmatic philosophy. By the 1880s, however, taste was clearly shifting toward a more cosmopolitan sophistication as patrons and painters alike saw themselves as members of an international community. That America turned increasingly to contemporary European art can be seen in a series of landscapes from the latter part of the century.

Peach Tree Bough, ca. 1867 (cat. no. 24), by Worthington Whittredge serves as a foil to these later developments, for it still relies upon a representation of the beauty of nature for its aesthetic validity. While nature is retained as the subject matter for the landscapes that follow in our series, abstract elements such as light, mass, color, brushwork, and tone assume greater importance. We can see George Inness moving in this direction in *The Coming Storm,* 1878 (cat. no. 29), in which literal realism gives way to studies of masses of light and color. Alexander H. Wyant, like Inness, began his career working in the tight, naturalistic Hudson River School style but had changed to a wispy Corot-like technique by the time he painted *Rocky Ledge, Adirondacks,* ca. 1905 (cat. no. 34). The subject may still be the American wilderness, but a French mode of vision has now been applied to it. Similarly, the American scene dissolves into a brilliant vision of Impressionistic light and color in *Nut Gathering,* ca. 1920–22 (cat. no. 45), by Willard Leroy Metcalf and *Amagansett, Long Island, NY,* 1920 (cat. no. 44), by Childe Hassam. Both Metcalf and Hassam had studied in Paris, where they learned to make pictures out of color, light, air, pattern, and rhythm. Artists soon realized that these abstract elements could be separated from and used independently of nature and objects—that art could be made from these formal elements alone—and the Modern era had arrived.

Wayne Craven
H. F. du Pont Winterthur Professor of Art History
University of Delaware

The Twentieth Century

Our country and our century. It might seem that it would be easier to describe and to understand the art of our own century better than any other, and it might seem that our country would always be known to us. Yet the paradox of this century lies in its complexity and its sense of alienation from those who dwell in it. American art in this century has been characterized as boisterous and striving, big and braggartly; it has been examined with regard to its European sources and its dependence on traditions; it has been viewed as a progression of discrete styles, from American Impressionism, Cubo-Futurism, and Synchromism to Neo-Expressionism and Neo-Abstractionism. As Robert Frost suggested in *The Black Cottage*, "Most of the change we see in life is due to truths being in and out of favor." American twentieth-century art has been such a suite of truths, none ever less than true, but no one truth lasting for the century.

We can see that this process of change has been the pattern for our century, but we can also see within the pattern of changes important forces at work: principles of style; ideas of the social responsibility of art; promptings of the heart and brush that seem ineffable but are essential facts; and splendid configurations of creative invention that fit into our pattern but alter it forever. Our century—with one last interval remaining to it—has been a remarkable one in American art. That it is ours may make it harder for us, finally, to see it, but it is no less fascinating.

To the assertion that twentieth-century visual art has been cut off from its traditional literary associations there is ample and clear refutation. Robert Motherwell's *The Tomb of Captain Ahab*, 1953 (cat. no. 75), is a literary and referential world in microcosm. Fascinated by *Moby-Dick*, as were many of his Abstract-Expressionist acquaintances, Motherwell understood the pragmatic American spirit's obsession with the ideal of perfect abstraction. Melville expressed this idealism in the whiteness of the whale, but the painter could interpret it in the very act of painting. In Motherwell's case, in the scant few inches of *The Tomb of Captain Ahab*, the artist explores the vastness of the oceans with the same concinnity with which Melville sought to understand human striving in the vast arena of nature.

This return for inspiration to the classic American novel shows the significance of historical and literary references to the contemporary painter. Learned and acute, Motherwell is in that respect much like other American artists of his and later generations. In fact, by the 1930s and 1940s, the United States was producing the largest number of college-educated or art-school-trained artists in the world. This education and training, made possible by American affluence, could be carried lightly or even scoffed at by some, but it had important consequences for American art in the post-war period, when the intellectual, knowledgeable artist became the counterpart of the intuitive, creative artist. To be sure, many earlier American artists were intelligent and educated, but only in the past few decades has knowledge of the American experience—our times, our past, our art—been so widely cultivated in schools and colleges.

If Motherwell can capture a voyage across an ocean within scarcely more than the compass of his hand, Edwin Dickinson, in *Bible Reading Aboard the Tegetthoff*, 1926 (cat. no. 47), employs the same image in a different way, recognizing that the gravest peril lies not in the passage but in one's separation from fellow passengers. Here, isolated and silent voyagers at a Bible reading fail to acknowledge their common journey.

The recent fervid celebration of the Statue of Liberty centennial attests to the intensity in American life of this myth of a passage over water to our shores, hearkening back not only to the Mayflower and other pioneering vessels but also to the immigrant ships of the nineteenth and twentieth centuries. What happens in both the Dickinson and the Motherwell paintings is nothing other than the exploration of origins, community, and destiny. These profound concerns reveal their work,

and American art of this century in general, to be deeply reflective and profoundly critical of the modern experience.

This kind of contemplation has a special place in the landscape, which provides the ground for thought as well as the physical presence of nature. Yasuo Kuniyoshi's *Empty Town in Desert*, 1943 (cat. no. 59), depicts a mournful ghost town with thick clouds overhead and grassy terrain encroaching in the foreground. Kuniyoshi begins with our conventional notions of an abandoned town and our association of such a site with a sense of loss, skillfully describing his town with just enough character to make it seem to have some specific characteristics, yet not enough to bar generalization. Our entrance into the most dilapidated structures in the middle ground of the painting allows us to infer that the background buildings will soon be equally decayed. Keeping close to narrative conventions, Kuniyoshi describes a small town as it might appear in a Western movie, yet he also gives us the latitude to see the painting as a symbol of the Old World and the near-Armageddon of the Second World War. We see the American small town, but we see war in Europe as well. Thus, while describing a here and now, he also evokes another world and another set of values. Kuniyoshi creates a landscape that comes perilously close to popular-culture cliché, yet he ends up depicting not just a town but the world.

Similarly, Georgia O'Keeffe's *Pelvis with Pedernal* of the same year, 1943 (cat. no. 60), confronts the problem of perception with the possibility of an altered, implicating landscape. O'Keeffe's alteration involves the juxtaposition of one order of nature with another; their manipulation bespeaks human presence and endeavor. The apparent similarity between a mountainous landscape and the smooth undulations of the pelvis creates a landscape that assumes the identity of a human being. Of course, we already recognize the existence of such conformities in nature (e.g., a tree trunk and the trunk of the body), but O'Keeffe creates such ambiguity of appearance that we risk entirely confusing one with the other. Her final effect, though, consists not merely in the magic of resemblances but in the alchemy of abstraction, where base materials are transmuted into the gold of abstract form. The ambiguity between pelvic ridge and mountain ridge becomes immaterial when we see the consonance of a nature subsumed within the larger perception of abstraction. Yet O'Keeffe's abstraction is not so different from Kuniyoshi's community of inferences, in that both paintings, from the same year, look for something transcendent in the landscape, and both find it.

To look to the landscape, as Edward Hopper does in *The Camel's Hump*, 1931 (cat. no. 50), and to experience the illusion of one form suggesting another is, in a way, to comprehend nature. But the illusion that Hopper refers to is not his alone, since the name "The Camel's Hump" undoubtedly goes back centuries. Through the name we not only know something of the place but something of the minds of those who have dreamed there.

The magnetism of the landscape marks American twentieth-century art. Even artists like Man Ray, chiefly known as cultivators of the mind, were drawn to it. In *Hills*, 1914–15 (cat. no. 41), Man Ray views his New Jersey terrain, scanning the distance between the fields and a succession of mountain ranges and unifying the whole by means of a tree in the foreground. Arthur B. Davies takes his garden beyond nature in *Jewel-Bearing Tree of Amity*, 1912 (cat. no. 40). Davies's dream world partakes of European eschatology as well as of an American Eden, thus excusing his maidens from the decorum of dress, but his sensitivity to the perfection of nature seems akin to O'Keeffe's three decades later. Both artists appear to believe in the possibility of the perfect land.

Our century has changed the American landscape. Many of its images have become urban, inflected by architecture, design, and advertising. In a century when landscape is revered, our relation to the urban environment has become uncertain. Positive images are possible, but searing negatives are more likely. Our literature abounds in indictments of the city. Bret Easton Ellis's recent novel *Less than Zero* ends with this picture of the urban nightmare: "Images of people, teenagers my own age, looking up from the asphalt and being blinded by the sun. These images

8

stayed with me even after I left the city. Images so violent and malicious that they seemed to be my only point of reference for a long time afterwards." These spectres of modern civilization represent the inevitable antagonism between the city and the natural condition of humankind.

A nature altered by humans is apparent in Preston Dickinson's *Fort George Hill,* 1915 (cat. no. 42), an early century example of the denial of nature in human building. Dickinson's hill is meanly sliced, and the severe geometry of a highway is imposed on the land. Signs and billboards obscure the foreground; a subway entrance tunnels into the mountain with no regard for its natural formation; the path up through a first level is lined with signs covering much of the landscape; and the hill is crested with tall buildings composed of undifferentiated units. Dickinson's precise vision of the institutionalized, advertised society is no less startling to us today in its fulfillment than it was in the artist's anticipation. For Dickinson, Fort George Hill has been destroyed by the dynamo of twentieth-century progress and can never be restored. He admonishes us and, in that admonition, assumes the role of the artist who predicts and judges.

Another view of the city can be found in Reginald Marsh's *Lower Manhattan,* 1930 (cat. no. 49), a broad view of Manhattan from the water at its base. Marsh was fascinated by New York but always spoke with ambiguity about urban values. Even his depiction of the architecture suggests such equivocation: the city is seen in broad view on a stubby base, upstaged by a tugboat in the foreground billowing heavy, dark smoke. Along with the choppy waters and the uncertain sky overhead, Marsh's tough view from the working tugboat denies the city its glamour and leaves it its soot and pollution.

Between suppositions of *Stadtluft-macht-frei* or Steffens's decay and despair, few can view the city clearly, but Charles Sheeler saw modern industry and its design in pristine majesty—as a sublime white city of cathedrals. In *New York No. 2,* 1951 (cat. no. 72), he expresses his confidence in the machine, in architecture, and in design. In the Gothic strivings of Sheeler's elegant and benign geometry, tall buildings cast shadows, but they also seem to create taller buildings and yet taller aspirations. In a view very different from Preston Dickinson's, buildings rise, even within the construction of the painting, to greater and purer heights, becoming serene symbols of the modern city, a New World Eden remade in the twentieth century. A similar spirit, with excitement, enthusiasm, and agitation, exists in Mark Tobey's *Partitions of the City,* 1945 (cat. no. 64), in which the urban fabric becomes the artist's canvas and urban diversity is offered as the raw material for the painting itself. Tobey's achievement is to see the city both under the control of the artist and marvelously out of control, with its many elements suggested but never fully refined in the painting.

While architecture and design may be the grandiloquent means by which the city expresses itself, the urban story is preeminently narrative. The cosmopolitan outing of Maurice B. Prendergast's *Landscape with Figures,* ca. 1912 (cat. no. 39), is a lyric of the urban park and pleasure akin to *Sunday Afternoon on the Island of the Grande Jatte* by Georges Seurat.

Seurat's earlier outing is more formal than Prendergast's, though Bostonian decorum is still operative for the American, and his story of a day outdoors is still governed by etiquette and reserve. Isabel Bishop treats the urban narrative with special verve, capturing the conversation of two women in *Double Date Delayed,* 1948 (cat. no. 69). Achingly awkward as a trio, the painting's figures could hardly be more expressive. The man in the middle sits with his hands clasped in his lap and his knees together as he foresees an agonizing evening in which the fourth person will never arrive. The two women bend forward in involved conversation to determine between themselves the future of the evening, oblivious to the discomfort of their companion. Plaintive and charming, Bishop's scene is worthy of an O. Henry story, a little urban drama we would too often fail to notice in real life but find fascinating under the sharper eye and in the unspoken clarity of Bishop's rendering. Bishop's acuity to dialogue and the drama of human communication is echoed in Romare Bearden's ingenious collage *Before the Dark,* 1971 (cat. no. 81). Egyptian art, Cubism, and Realist conventions are melded by Bearden into a tale of the modern city, a trio of figures as fascinatingly interconnected as those in the Bishop painting.

9

The urban fabric is also revealed through episodes in the lives of individuals. For example, Joe Jones's insightful *Portrait of the Artist's Father,* 1932 (cat. no. 52), depicts a man near a stove, bottle and glass within reach, pipe not far away. Yet, from the way he peers into the corner with his hand over his ear, we can see that these objects of security are not enough. The bowler hat gives him the appearance of Everyman, like Charlie Chaplin, and his black suit creates a somber, even mournful atmosphere. Countless figures in American twentieth-century letters, including Gatsby and Willy Loman, confront in themselves an unmitigated aloneness like that of the artist's father, and it is this solitude that becomes the subject of the painting. The warmth from the stove, the bottle and glass, the pipe—they are all insufficient. Gazing into the corner with his back to us, Jones's figure is tragically typical of contemporary unhearing, unspeaking sadness. The shrewd dressing of the scene reminds us of the stage designer's craft, which alerts us to every idiosyncracy of a play's character before we set eyes on the actors. The tragedy of this individual is that, while we will not see him face to face, we already know him, painfully, through the scene that has been set in the painting. He is an individual revealed in his objects.

In Alexander Brook's *The Yellow Fan,* 1930 (cat. no. 48), one person is able to portray, simultaneously, dressing and the undressed, elegance and inelegance, freshness and fatigue. The beauty of the yellow fan—and its suggestion of fluttering insouciant charm—and the beauty of its bearer are reduced by her fatigue and by our ability in art to see people as they really are, without artifice. Walt Kuhn's *Camp Cook,* 1931 (cat. no. 51), expresses a similar poignancy. Kuhn can see through a circus clown and a woman of society to reveal the characters beneath, and there is no guile in his straightforward presentation of the cook at work. He looks straight out at us, never stopping his chore, in a way that is as unyielding as his difficult labor. His dignity is in his bearing as a no-nonsense, meat-and-potatoes cook, representing the American ideal of the simple, heroic figure. In the depiction of these three individuals, we find an acute perception of the characteristics that the twentieth-century person seeks. Among the three, the lowly camp cook is the hero, because of his straightforward, unpretentious honor and because he gives himself to his task even as he is being painted. Patrician portraiture and the art of embellishment play small roles in this century. Ernest Hemingway offered this advice: "The first and most important thing of all, at least for writers today, is to strip language clean, to lay it bare down to the bone." Kuhn does the same in his descriptive painting.

A simple life is the American ideal, even in a complex century. For George F. Babbitt, the events and effects of daily life were the most important: "A sensational event was changing from the brown suit to the gray the contents of his pockets. He was earnest about these objects. They were of eternal importance, like baseball or the Republican Party." Similarly, in Kenneth Hayes Miller's *The Morning Paper,* 1938 (cat. no. 55), reading over coffee is an ordinary act in an extraordinary painting. The sitter possesses the style and the self-confidence and creates the impact of Northern Baroque interior paintings while engaged in the most mundane activity. Similarly, Raphael Soyer's *Study for Sentimental Girl,* 1934 (cat. no. 53), conveys the sentiment while capturing the dignity of the single figure as she sits in contemplation.

A like honesty prevails in many American paintings of objects. Milton Avery's *Pink Tablecloth,* 1944 (cat. no. 61), depicts a kitchen without embellishment or aggrandizement. The straightforward, unpretentious manner in which the objects and the food are presented reflects the kind of simplicity we associate with American cuisine, as well as with more general aspects of our national character. The interior with a view onto the water by Marsden Hartley, in *Summer—Sea Window No.* 1, 1939–40 (cat. no. 56), shows how the European tradition of an elaborated view, with convoluted relations between interior and exterior, has been rejected. In its place is a simple scene, establishing a contrast between the space of the room and the larger exterior space beyond. Style avoids subterfuge in such a painting. There is no deceit, no virtuoso performance, to demonstrate the skill of the artist. The skill of Hartley's work lies in the self-evident grace with which it captures our perception of a simple scene.

The forces of abstract painting in America are also preeminently those of simplification and honesty. Even though a painting may offer us something different from our retinal impression of the world, its objective may be no less truthful. Indeed, abstraction may often be measured, as in Franz Kline's *The Bridge,* ca. 1955 (cat. no. 77), by the extent to which the viewer can discover new truths in the painting. The vertical mass of the bridge and its horizontal span over water are evident in the Kline painting, and in this regard it is a representational painting. But, Kline also purifies these elements into the signs of abstraction, thereby allowing us to understand the engineering of the bridge through the simple eloquence of a visual metaphor.

Perhaps the Kline is not too different from George Luks's *Roundhouses at Highbridge,* 1909–10 (cat. no. 38), a painting that also looks at modern technology. Luks perceives the abstract potential of a city subsumed into a vista, a river as a pattern of line, and the smoke of trains as part of a vertical rainbow made by human beings. That nature and modern civilization together offer such rich opportunities for abstraction is no less apparent to Luks than to Kline. This is not to argue that Luks would have been an abstract painter had he been born a few decades later, but to recognize both the abstract striving and the observational adherence of Kline in his painting. We need not see the water to know that it is there; we need not see specific structural elements of the bridge to perceive their significance or beauty. In fact, in not seeing those specifics, we become even more alert to the new possibilities of mind and form that Kline allows us in transforming three-dimensional reality into a flat impression.

Hans Hofmann's *Untitled,* 1962 (cat. no. 80), calls us to the similar task of seeing beyond resemblance, of understanding that painting is inherently the drama of two-dimensional configuration. We discover in the Hofmann a wonderfully steady balance that testifies to our ability to find equilibrium in the world of three-dimensional objects. Ilya Bolotowsky's *Diamond Shape,* 1952 (cat. no. 73), also compels us to understand the dynamics of composition on the plane of the picture, and those dynamics are made even more apparent by the dislocation Bolotowsky provides in transmogrifying a simple square into an apparently more difficult diamond. To be sure, we realize that the difficulty of the diamond is illusory when we recall that it is simply a square and that its configuration is well known to us. We can be as at home with these abstractions as with any representational image, finding our way by means of association and knowledge.

Morgan Russell's *Synchromie Cosmique,* 1915 (cat. no. 43), points to one of the cognitive sources of American abstract painting. Seeking a scientific understanding of color, Russell brought the color wheel—and the combination of colors in the creation of new color and form—directly onto the canvas. This investigation of color has been zealously pursued by many subsequent American artists, including Mark Rothko, whose *Untitled: Abstraction Number II,* 1947 (cat. no. 68), reveals the possibilities of color when realized within formal abstraction. In its most dynamnic form, an understanding of color and its potential to create an abstract world is offered in Jackson Pollock's *No. 34,* 1949 (cat. no. 70). In a superb example of his action painting, Pollock uses a swirling calligraphy of line and color to give birth to a warren of images and to create a composite image of painting as a deliberate, exuberant act. Pollock's goal is to make us see both the painterly passages of the painting and the whole painting—just as we can watch a dance performance and simultaneously see the steps of the dancer. His achievement is that we do see both, just as we see Bolotowsky's transfer from the square to the diamond and just as we follow the simple narratives of the representational painters.

Our century has indeed been remarkable. Among the many characteristics of major American paintings in this century, it would be impossible to find one that applies to all. But the hard-to-define characteristics of practical honesty and simplicity are as easy to find in American art as they are in the American character. As F. Scott Fitzgerald remarked, "France was a land, England a people, but America, having about it still the quality of an idea, was harder to utter—it was a willingness of the heart." Indeed, this humanely comprehensive idea, a willingness of the heart, may encompass a wide range of styles in twentieth-century American painting. In quests for

abstract forms, in landscape, in confrontations with complex urban life and architecture, and in the stories of communities and individuals, there is a common artistic idea that may suggest the meaning of this century. William Faulkner put it this way: the writer—or, in our case, the artist— "must teach himself that the basest of all things is to be afraid; and teaching himself that, forget it forever, leaving no room in his workshop for anything but the old verities and truths of the heart, the old universal truths lacking which any story is ephemeral and doomed—love and honor and pity and pride and compassion and sacrifice." What Faulkner described in 1950 had already been the American artist's mission for decades, and it remains so today—a mission of heart and confidence, acclaiming the value of art and the worth of the individual in the most complex, most troubled, and most powerful society of any time or any place. Through this willingness of the heart, American art asserts, without word but in myriad images, that humanity will endure.

Our country and our century have been burdened by an unrelenting history with power and responsibility far greater than those of any prior civilization. In dealing with this power and responsibility, we do well to look to the lessons of American twentieth-century painting. The lessons are so simple and so direct that they hardly seem lessons at all. Instead, they are warm affirmations of nature valued, tales of strength and concern, ideas of aspiration, and episodes of individual and community. They are lessons in an old-fashioned way. They are, as well, a promise that we continue to hold our responsibility and our civilization dear. Few cultures have asked so much of art as we ask of our art in our century.

Richard Martin
Executive Director, Shirley Goodman Resource Center
Fashion Institute of Technology
New York, New York

Catalogue of the Exhibition

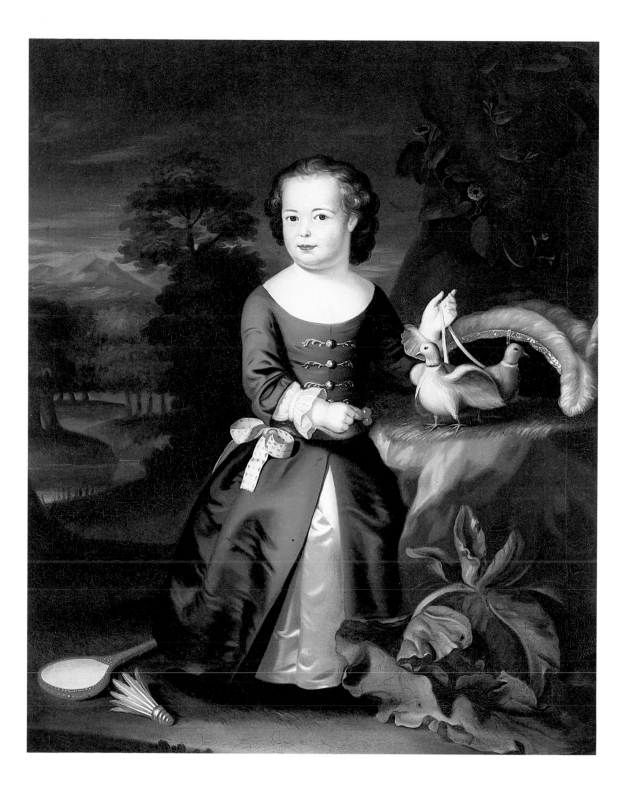

1.
John Singleton Copley (1738–1815)
Thomas Aston Coffin. ca. 1758

Oil on canvas
50 x 40
Museum Purchase 58.1

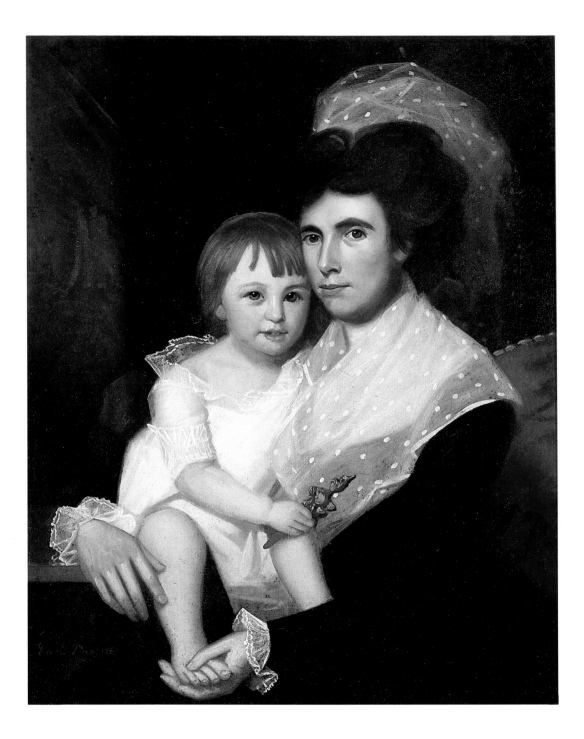

2.
Ralph Earl (1751–1801)
Mrs. James Watson and Son James Talcott. 1788

Oil on canvas
34 ¼ x 27 ⅜
Proctor Collection PC.41

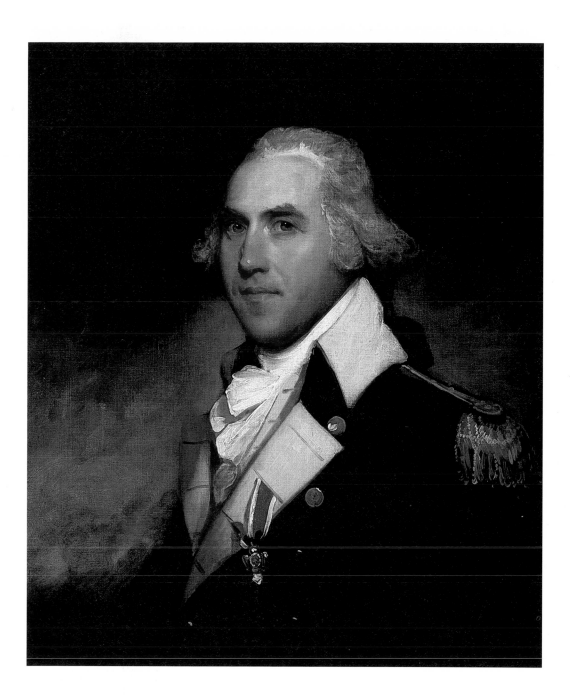

3.
Gilbert Stuart (1755–1828)
General Peter Gansevoort. ca. 1794

Oil on canvas
30⅛ x 25⅛
Museum Purchase 54.88

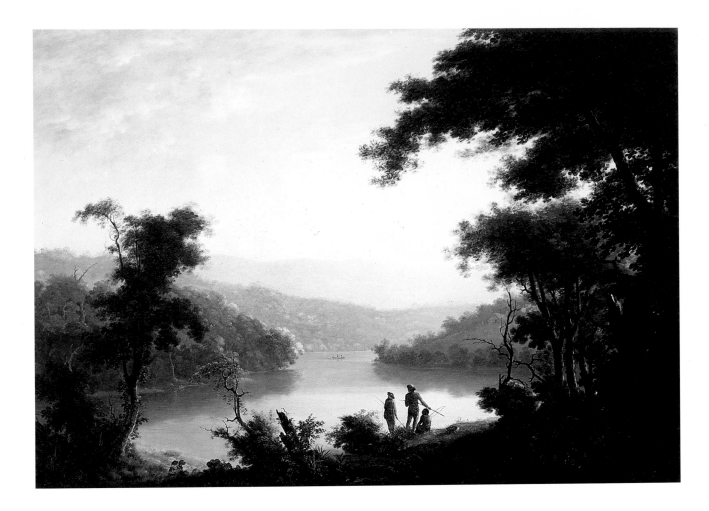

4.
William Winstanley (1775–1806)
*The Meeting of the Potomac
and Shenandoah Waters
at Harper's Ferry*. 1795

Oil on canvas
45⅛ x 59⅜
Museum Purchase 63.94

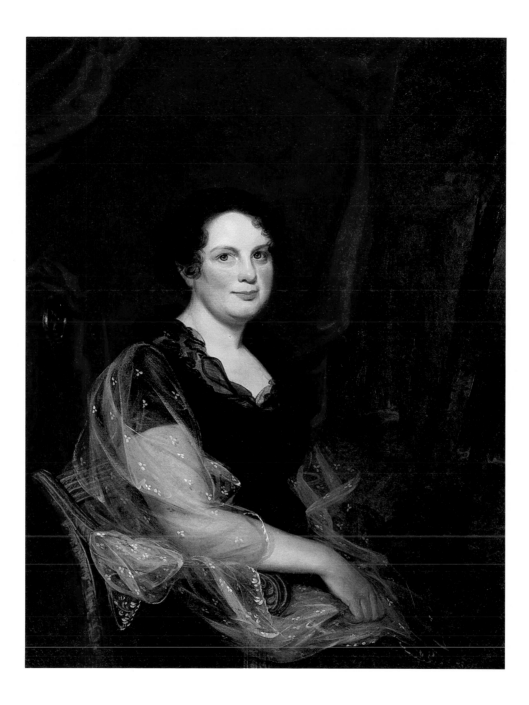

5.
John Wesley Jarvis (1780–1840)
Mrs. John Leake Norton. ca. 1815

Oil on canvas
40¼ x 30½
Museum Purchase 66.5

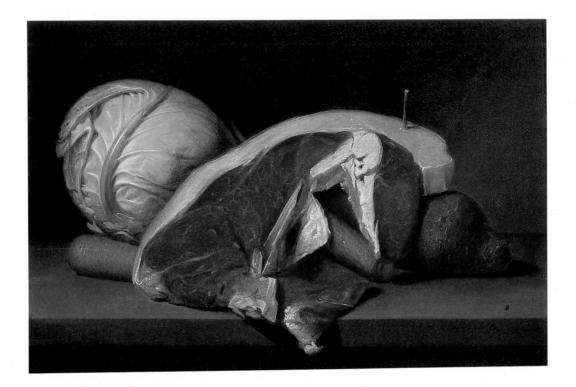

6.
Raphaelle Peale (1774–1825)
Still Life with Steak. ca. 1817

Oil on wood
13⅜ x 19½
Museum Purchase 53.215

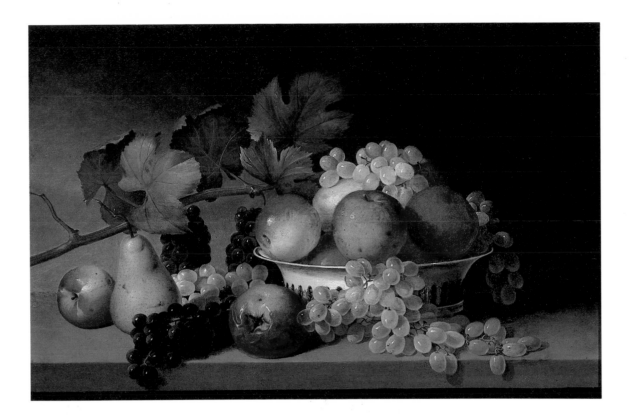

7.
James Peale (1749–1831)
Still Life—Apples, Grapes, Pear. 1824–26?

Oil on wood
18⅛ x 26½
Museum Purchase 78.45

21

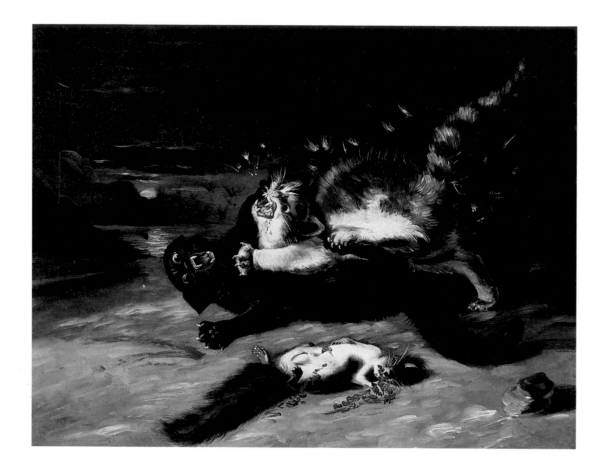

8.
John James Audubon (1785–1851)
Two Cats Fighting. 1826

Oil on canvas
28 x 36
Museum Purchase 70.66

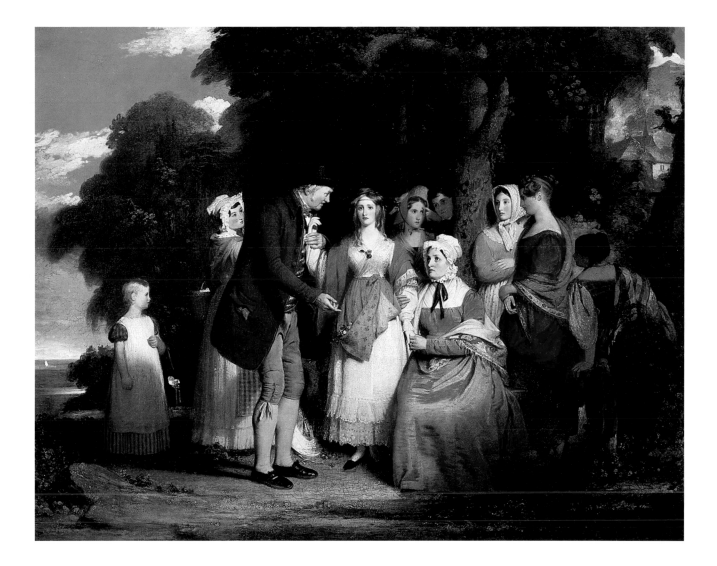

9.
William E. West (1788–1857)
Annette de l'Arbre. 1831

Oil on canvas
44 3/8 x 56 1/8
Museum Purchase 60.328

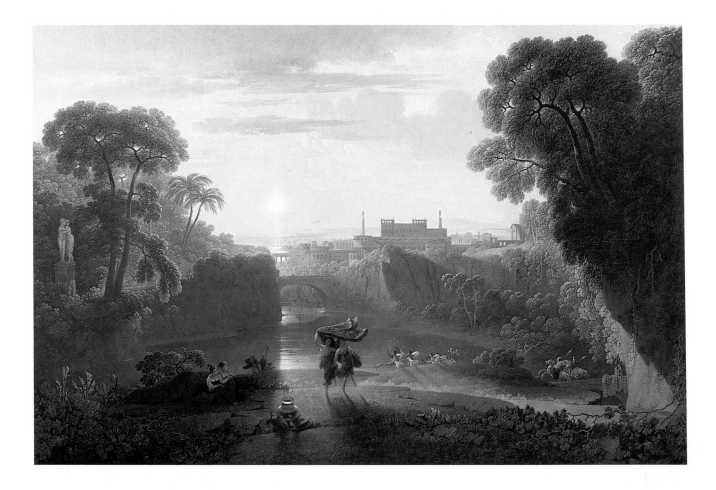

10.
Joshua Shaw (1776/77–1860)
Morning, Distant View of Carthage—
Dido and Aeneas Going to the Hunt. ca. 1831

Oil on canvas
25 x 37½
Museum Purchase 60.197

II.
John Quidor (1801–1881)
*Anthony Van Corlear Brought
into the Presence
of Peter Stuyvesant.* 1839

Oil on canvas
27 3/8 x 34 1/2
Museum Purchase 63.110

25

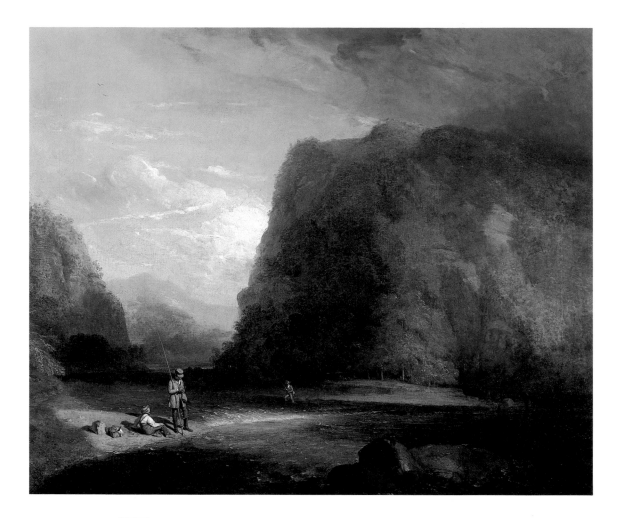

12.
Henry Inman (1801–1846)
Trout Fishing in Sullivan County, New York. ca. 1841

Oil on canvas
25 x 30
Museum Purchase 83.14

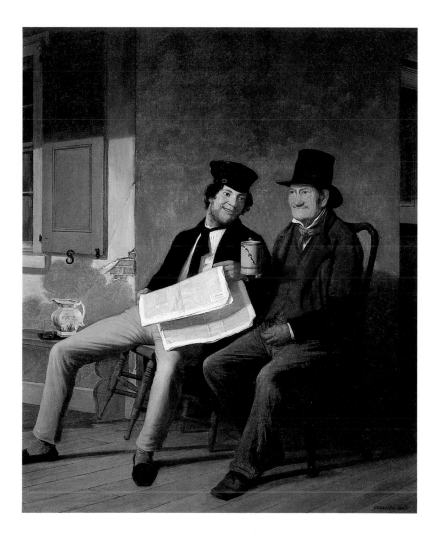

13.
James Goodwyn Clonney (1812–1867)
Mexican News. 1847

Oil on canvas
26⅝ x 21¾
Museum Purchase 66.73

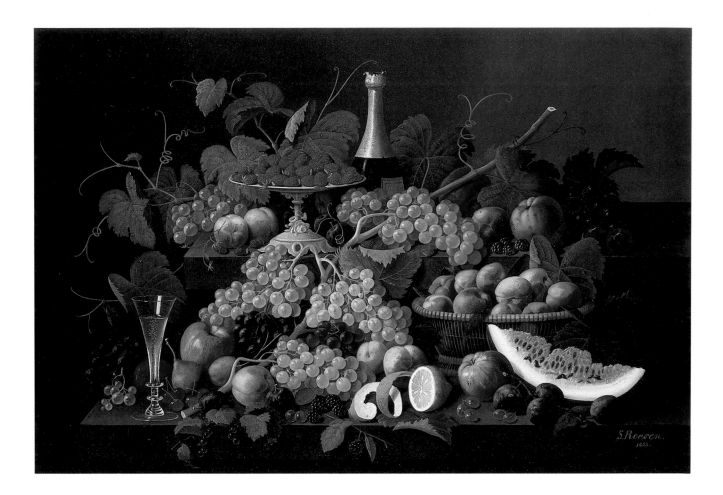

14.
Severin Roesen (active ca. 1847–ca. 1871)
Still Life with Fruit and Champagne. 1853

Oil on canvas
30 x 44
Museum Purchase 82.53

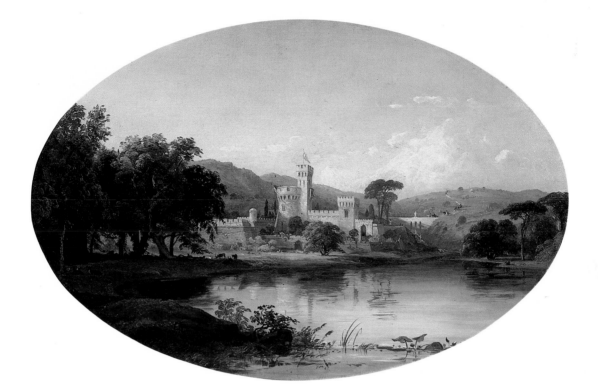

15.
Jasper F. Cropsey (1823–1900)
Castle by the Lake. 1855

Oil on canvas
17½ x 27 (oval)
Museum Purchase 60.195

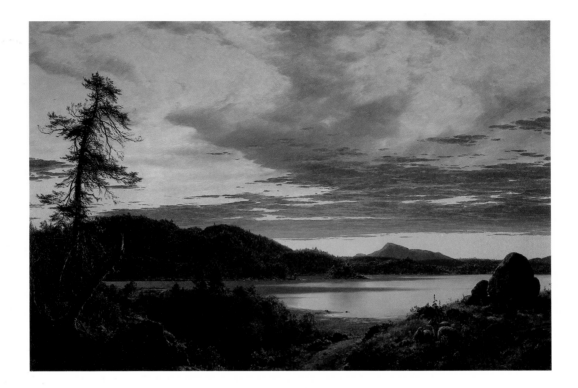

16.
Frederic Edwin Church (1826–1900)
Sunset. 1856

Oil on canvas
24 x 36
Proctor Collection PC.21

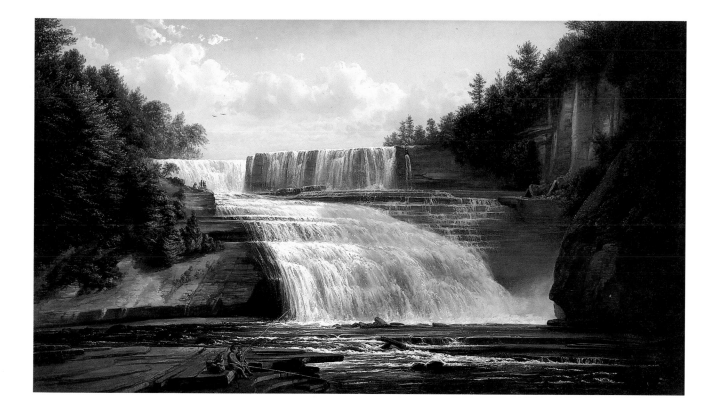

17.
Ferdinand Richardt (1819–1895)
Trenton Falls. 1858

Oil on canvas
35⅞ x 62½
Institute Collection 72.53

18.
David Gilmour Blythe (1815–1865)
Washday. ca. 1858

Oil on canvas
17 x 13⅛
Purchased with funds from
the Charles E. Merrill Trust 73.113

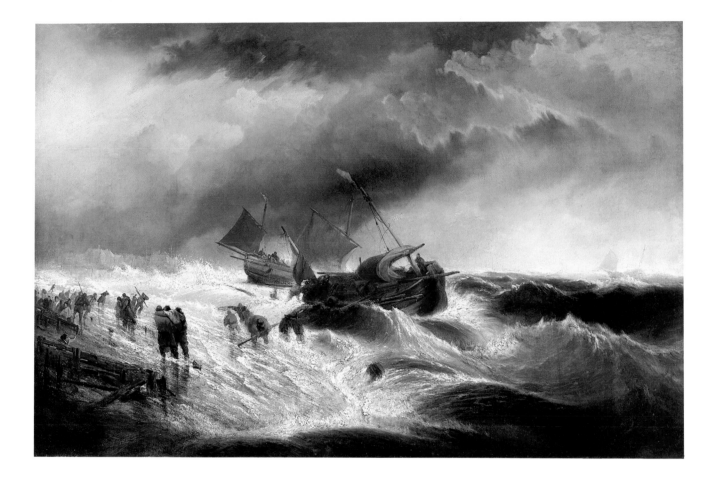

19.
Edward Moran (1837–1926)
Shipwreck. 1862

Oil on canvas
30 x 40
Museum Purchase 81.13

20.
Arthur Fitzwilliam Tait (1819–1905)
Mink Trapping in Northern New York. 1862

Oil on canvas
20½ x 30½
Museum Purchase 67.92

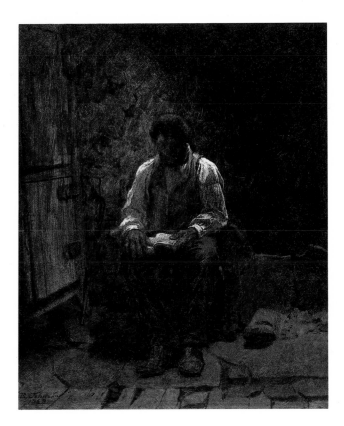

21.
Eastman Johnson (1824–1906)
The Chimney Corner. 1863

Oil on board
15½ x 13
Gift of Mr. Edmund G. Munson, Jr. 64.116

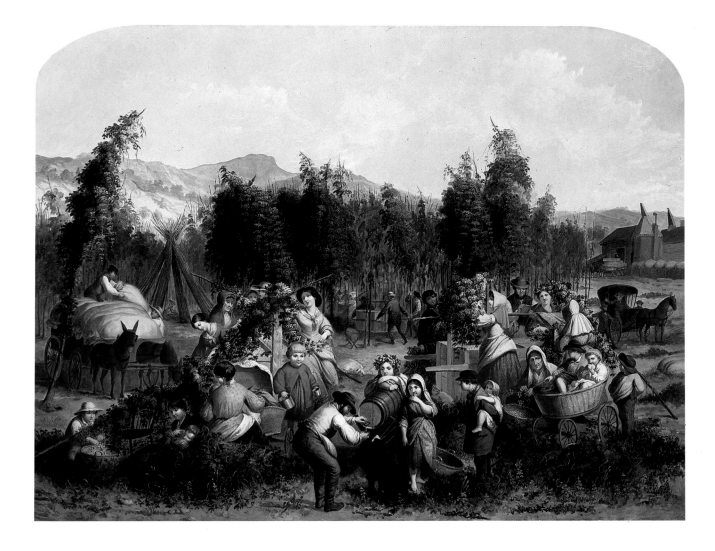

22.
Tompkins H. Matteson (1813–1884)
Hop Picking. 1863

Oil on canvas
38¼ x 50¼
Museum Purchase 49.11

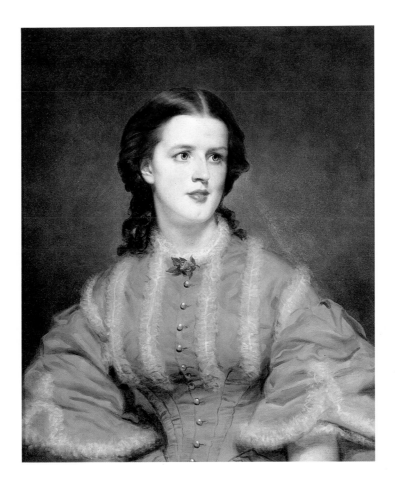

23.
Charles Loring Elliott (1812–1868)
Cornelia Perkins. 1864–65

Oil on canvas
27 x 22
Gift of Oneida Historical Society 58.90

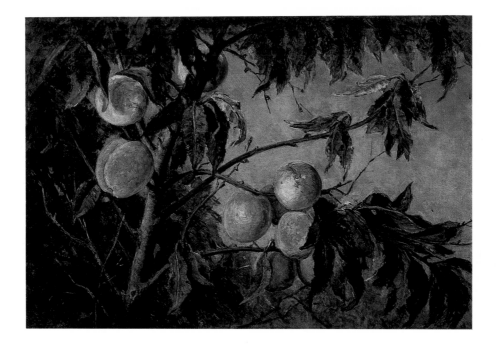

24.
Worthington Whittredge (1820–1910)
Peach Tree Bough. ca. 1867

Oil on canvas
15½ x 22¼
Museum Purchase 65.28

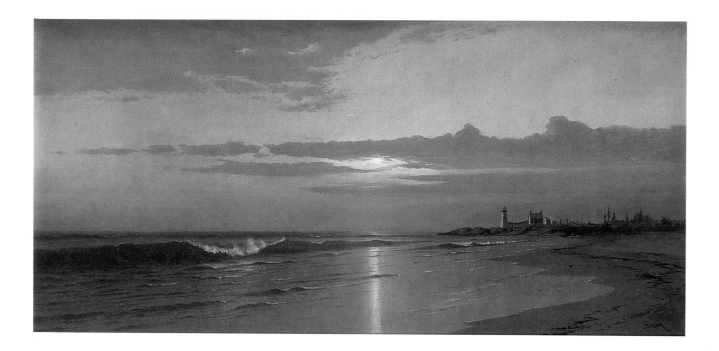

25.
Francis A. Silva (1836–1886)
Sunrise: Marine View. ca. 1870

Oil on canvas
15 x 30
Museum Purchase 85.45

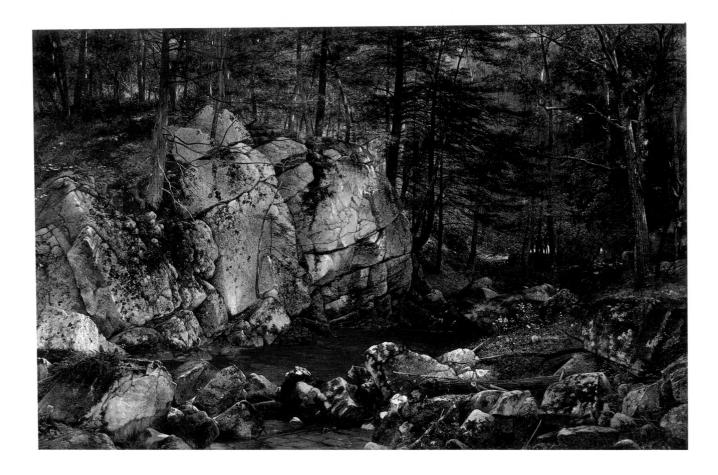

26.
David Johnson (1827–1908)
Brook Study at Warwick. 1873

Oil on canvas
25⅞ x 39⅞
Proctor Collection PC.62

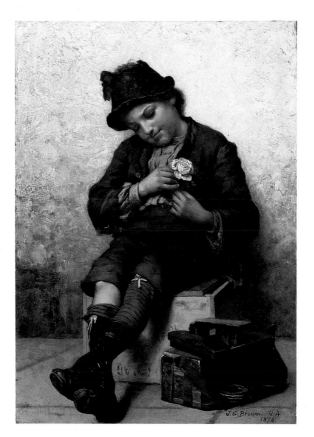

27.
John G. Brown (1831–1913)
Bootblack with Rose. 1878

Oil on canvas
20 x 14
Proctor Collection PC.11

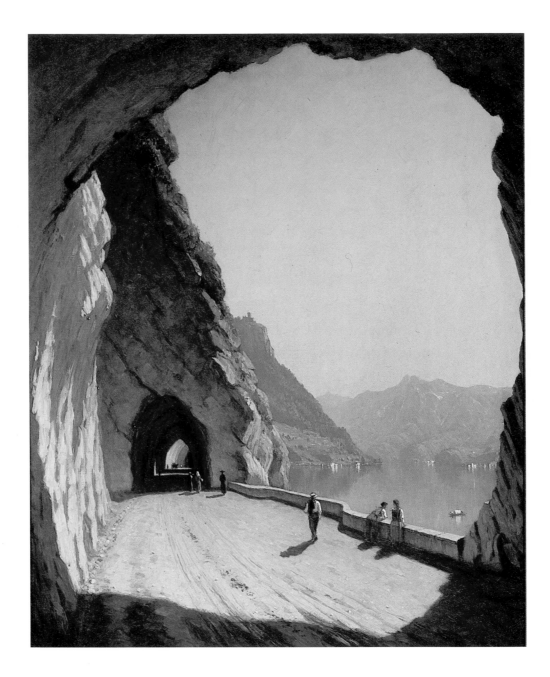

28.
Sanford Robinson Gifford (1823–1880)
Galleries of the Stelvio, Lake Como. 1878

Oil on canvas
30½ x 24½
Proctor Collection PC.48

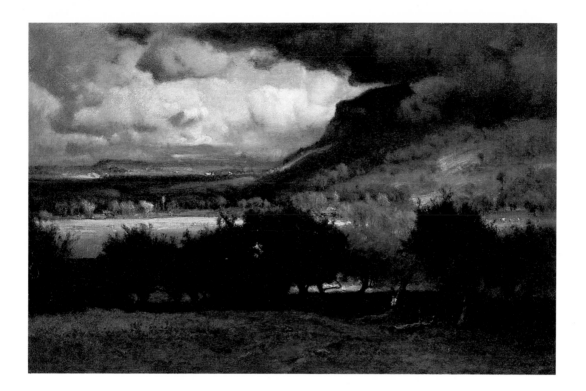

29.
George Inness (1825–1894)
The Coming Storm. 1878

Oil on canvas
16⅛ x 24
Museum Purchase 54.73

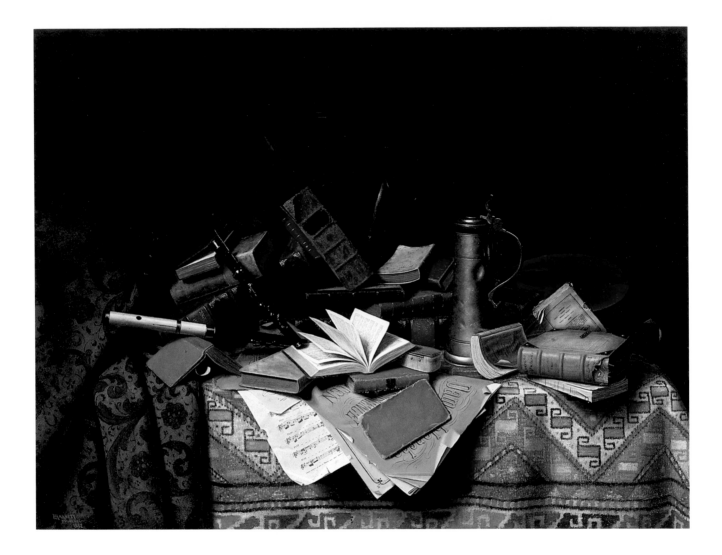

30.
William M. Harnett (1848–1892)
A Study Table. 1882

Oil on canvas
39⅞ x 51⅜
Museum Purchase 57.67

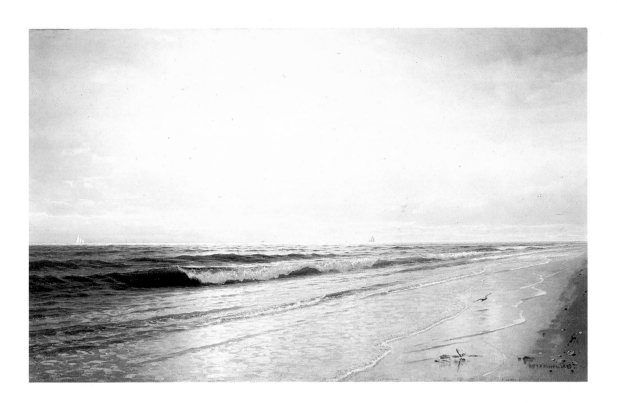

31.
William Trost Richards (1833–1905)
Summer Clouds. 1883

Oil on canvas
23⅛ x 37
Proctor Collection PC.93

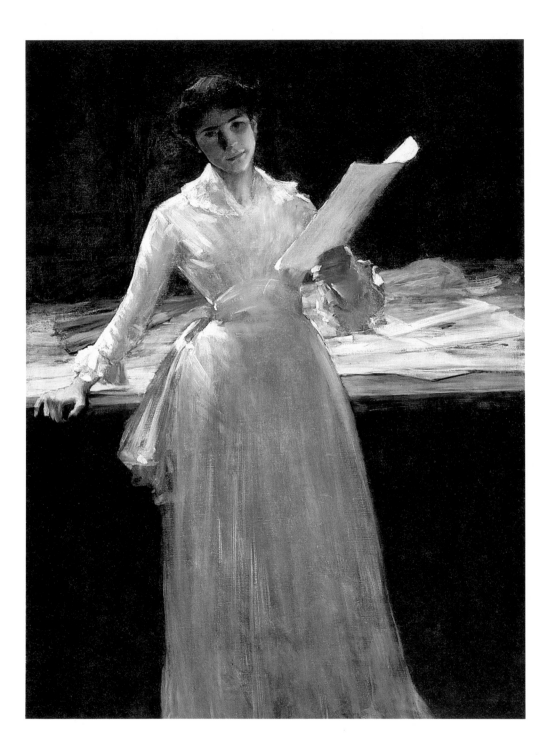

32.
William Merritt Chase (1849–1916)
Memories. 1885–86

Oil on canvas
51 x 36½
Museum Purchase 57.305

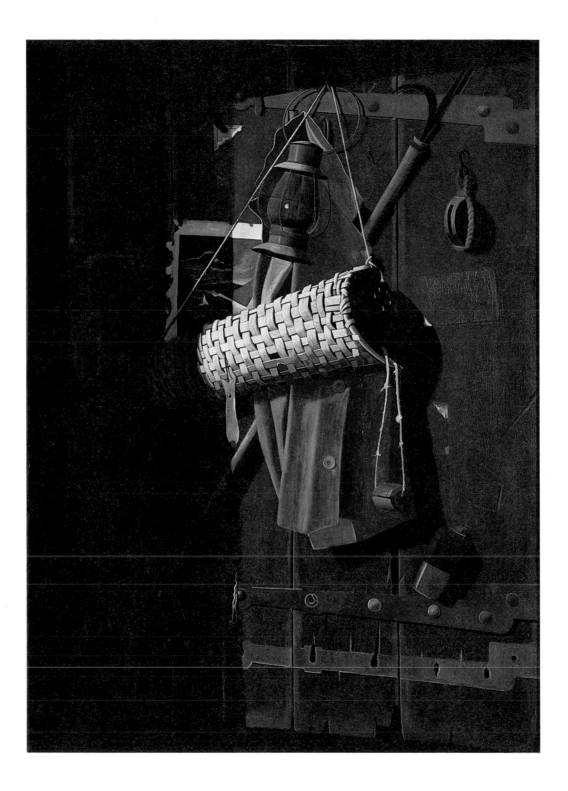

33.
John F. Peto (1854–1907)
Fishhouse Door with Eel Basket. ca. 1890

Oil on canvas
59½ x 42⅞
Museum Purchase by exchange 65.15

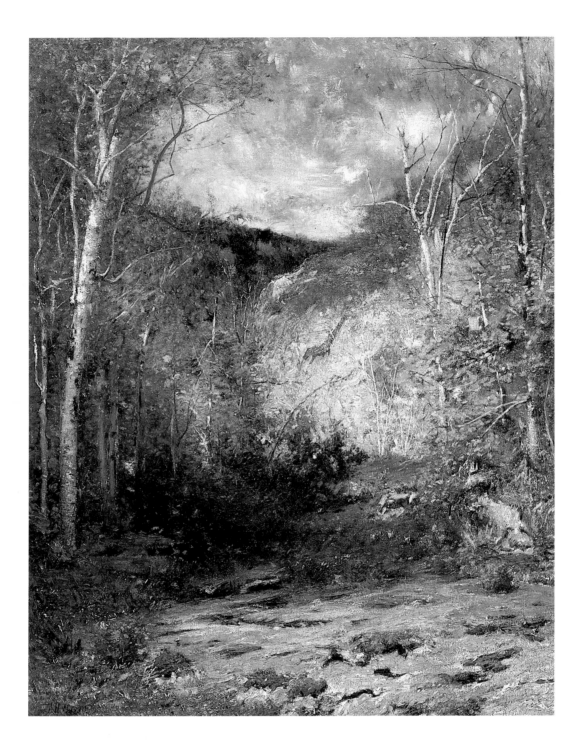

34.
Alexander Helwig Wyant (1836–1892)
Rocky Ledge, Adirondacks. ca. 1905

Oil on canvas
42¾ x 33½
Museum Purchase 64.146

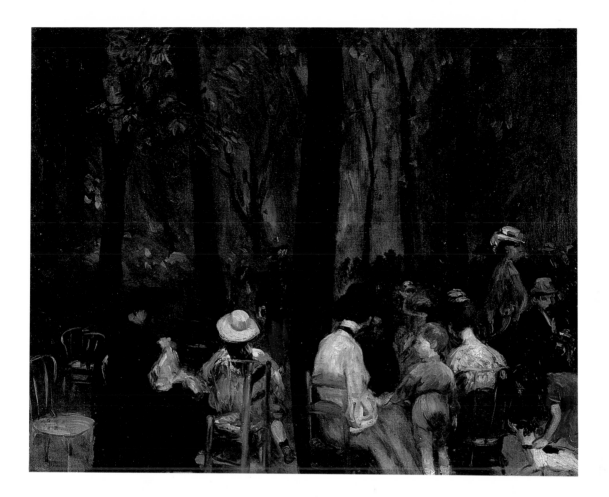

35.
William Glackens (1870–1938)
Under the Trees, Luxembourg Gardens. 1906

Oil on canvas
19¾ x 24¼
Museum Purchase 50.15

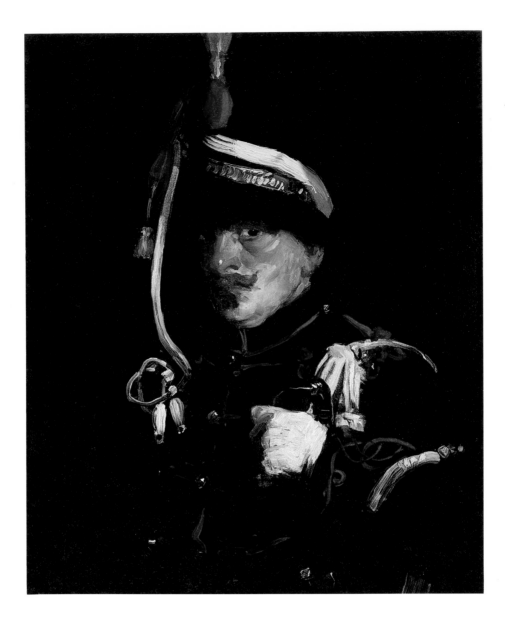

36.
Robert Henri (1865–1929)
Dutch Soldier. 1907

Oil on canvas
32 ⅝ x 26 ⅛
Museum Purchase 58.8

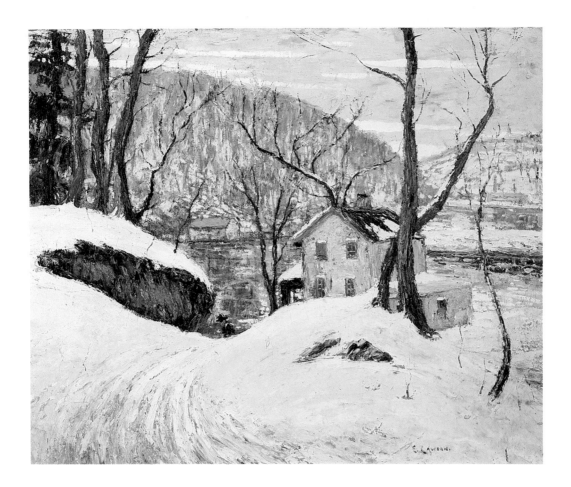

37.
Ernest Lawson (1873–1939)
Winter, Spuyten Duyvil. ca. 1908

Oil on canvas
25⅛ x 30
Museum Purchase 58.41

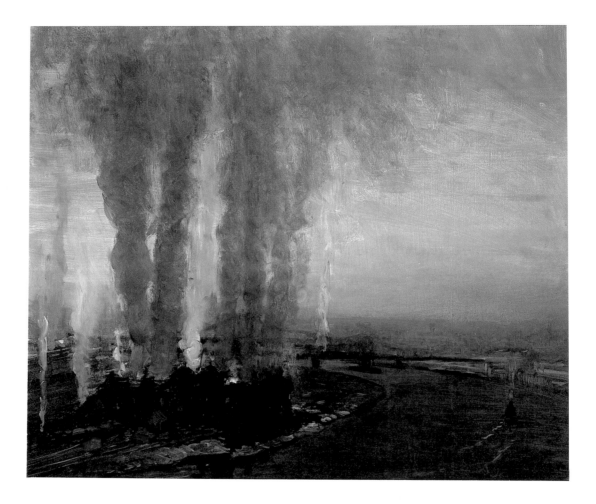

38.
George Luks (1866–1933)
Roundhouses at Highbridge. 1909–10

Oil on canvas
30⅜ x 36⅛
Museum Purchase 50.17

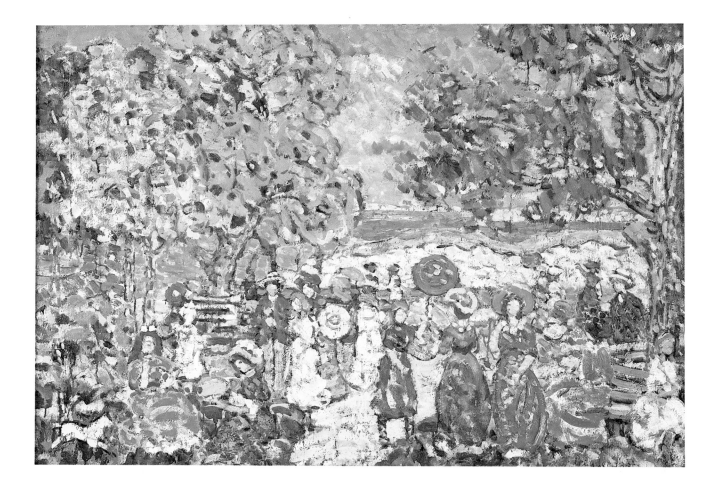

39.
Maurice Prendergast (1859–1924)
Landscape with Figures. ca. 1912

Oil on canvas
29³/4 x 42¹³/16
Edward W. Root Bequest 57.212

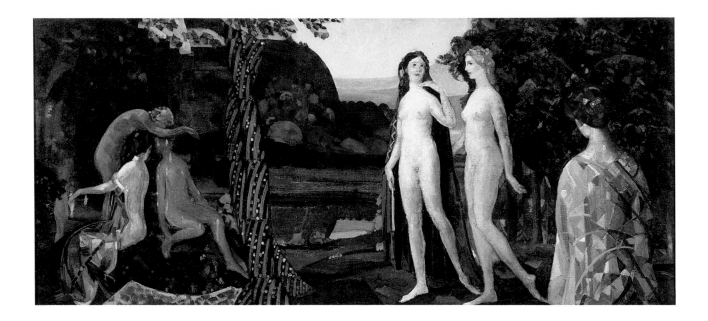

40.
Arthur B. Davies (1862–1928)
Jewel-Bearing Tree of Amity. 1912

Oil on canvas
18 x 40
Museum Purchase 56.5

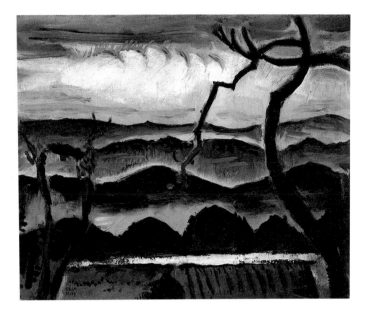

41.
Man Ray (1890–1977)
Hills. 1914–15

Oil on canvas
10 x 12
Museum Purchase 86.1.2

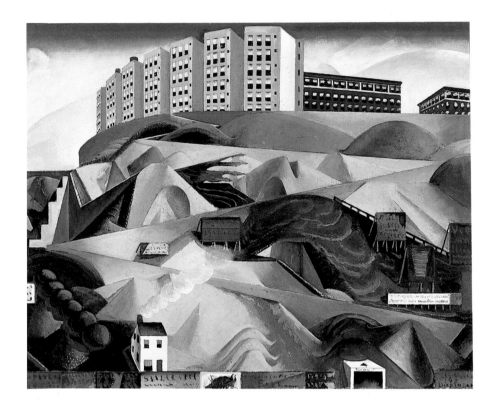

42.
Preston Dickinson (1891–1930)
Fort George Hill. 1915

Oil on canvas
14 x 17
Edward W. Root Bequest 57.132

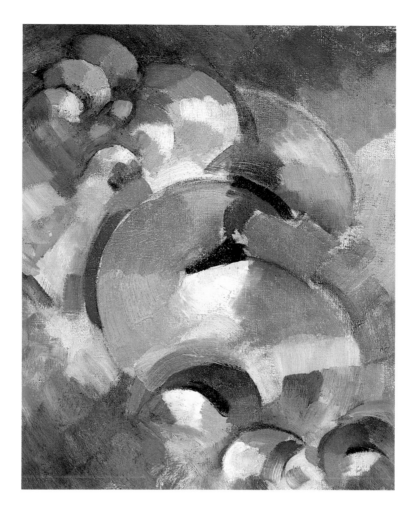

43.
Morgan Russell (1886–1953)
Synchromie Cosmique. 1915

Oil on canvas
16½ x 13¼
Museum Purchase 57.26

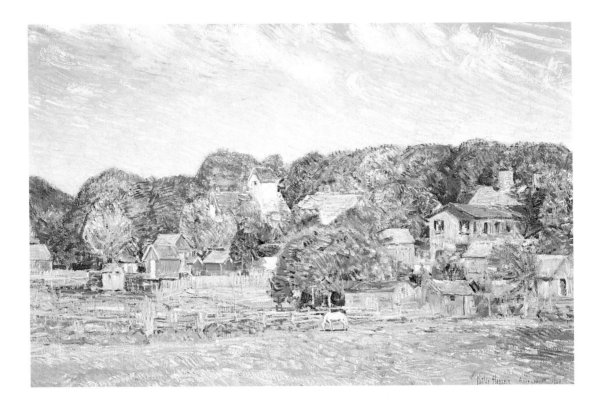

44.
Childe Hassam (1859–1935)
Amagansett, Long Island, NY. 1920

Oil on canvas
20 x 30
Museum Purchase 58.7

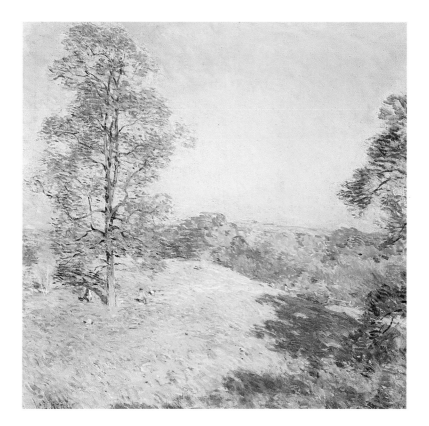

45.
Willard Leroy Metcalf (1858–1925)
Nut Gathering. ca. 1920–22

Oil on canvas
24 ¼ x 24 ½
Purchased with funds from
the Charles E. Merrill Trust 73.160

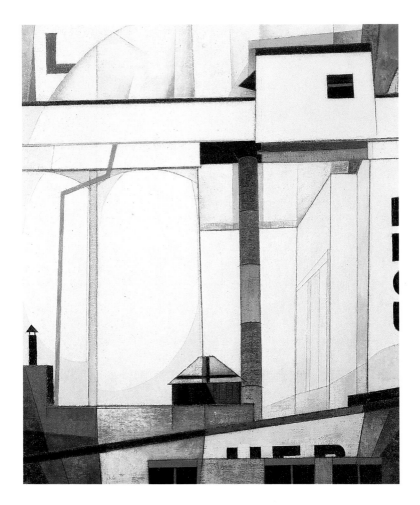

46.
Charles Demuth (1883–1935)
Nospmas. M. Egiap Nospmas. M. 1921

Oil on canvas
20 x 24
Museum Purchase 68.29

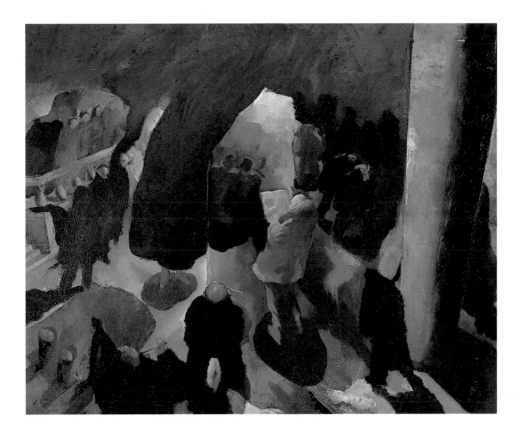

47.
Edwin Dickinson (1891–1978)
Bible Reading Aboard the Tegetthoff. 1926

Oil on board
19^7/$_8$ x 23^{13}/$_{15}$
Gift of Mr. and Mrs. Ferdinand H. Davis 68.36

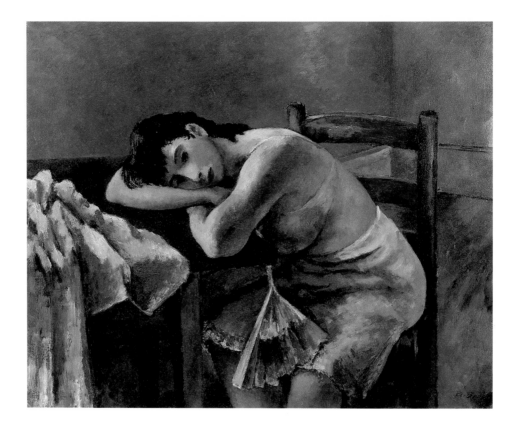

48.
Alexander Brook (1898–1980)
The Yellow Fan. 1930

Oil on canvas
30⅛ x 36
Edward W. Root Bequest 57.88

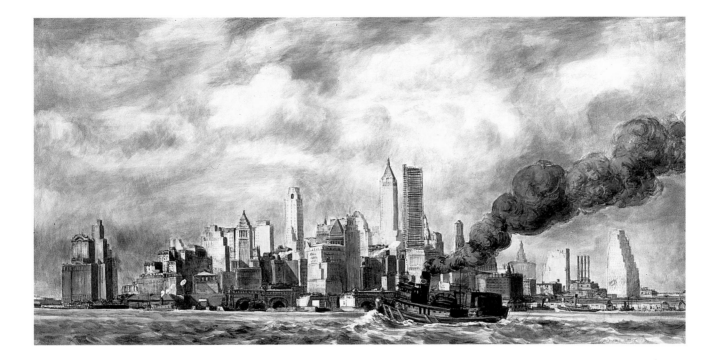

49.
Reginald Marsh (1898–1954)
Lower Manhattan. 1930

Tempera on Masonite
24 x 48
Edward W. Root Bequest 57.195

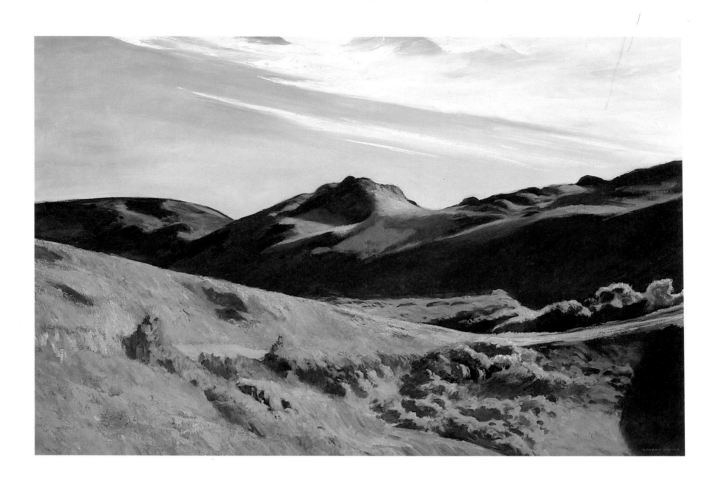

50.
Edward Hopper (1882–1967)
The Camel's Hump. 1931

Oil on canvas
32¼ x 50⅛
Edward W. Root Bequest 57.160

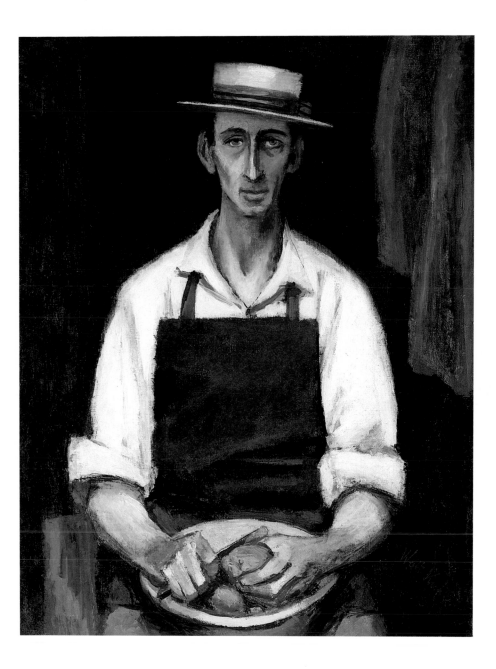

51.
Walt Kuhn (1877–1949)
Camp Cook. 1931

Oil on canvas
40 x 30
Museum Purchase 57.307

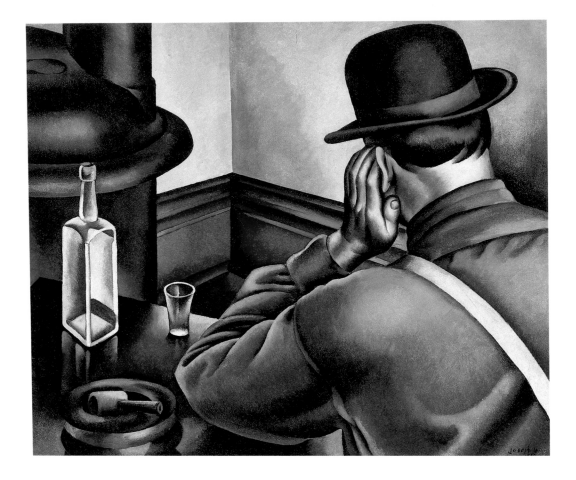

52.
Joe Jones (1909–1963)
Portrait of the Artist's Father. 1932

Oil on canvas
36½ x 30
Museum Purchase 83.13

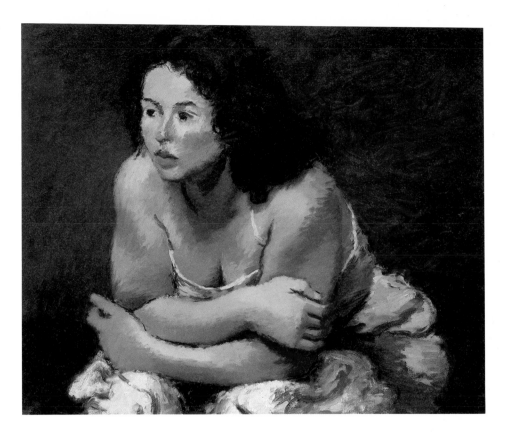

53.
Raphael Soyer (b. 1899)
Study for Sentimental Girl. 1934

Oil on canvas
20 x 24
Edward W. Root Bequest 57.236

54.
Clyfford Still (1904–1980)
Brown Study. 1935

Oil on canvas
29 $^{15}/_{16}$ x 20 $^{1}/_{4}$
Museum Purchase 75.65

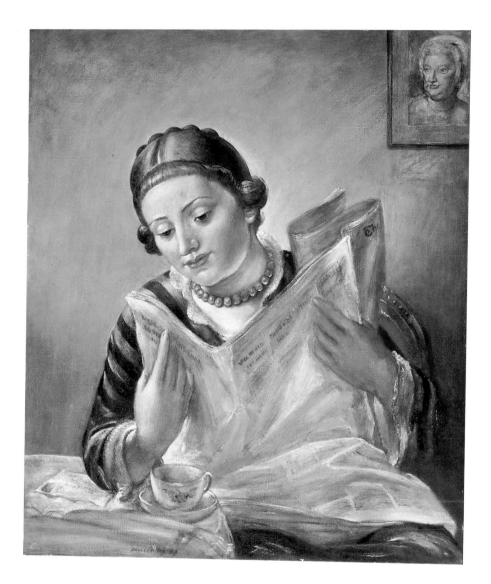

55.
Kenneth Hayes Miller (1876–1952)
The Morning Paper. 1938

Oil on canvas
30 x 25
Museum Purchase 53.211

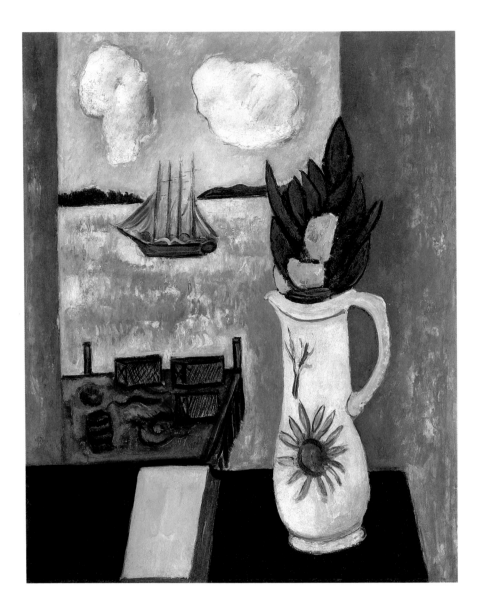

56.
Marsden Hartley (1877–1943)
Summer—Sea Window No. 1. 1939–40

Oil on academy board
28 x 22
Museum Purchase 72.37

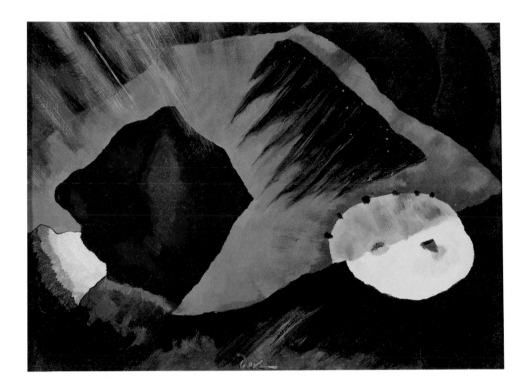

57.
Arthur Dove (1880–1946)
No Feather Pillow. 1940

Oil and wax emulsion on canvas
16 x 22
Edward W. Root Bequest 57.134

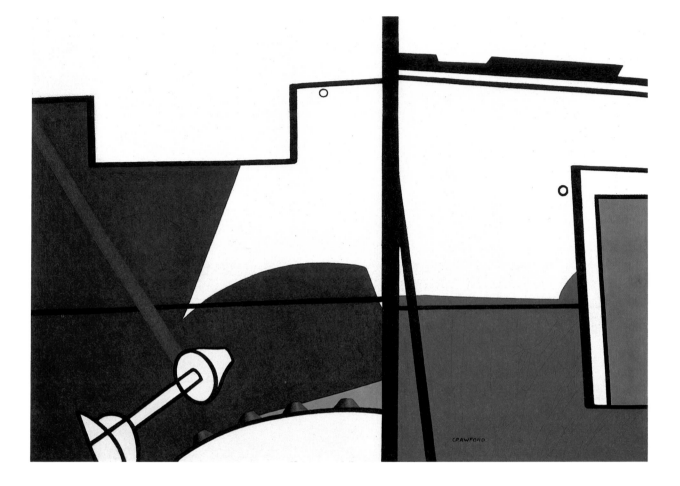

58.
Ralston Crawford (1906–1978)
Boiler Synthesis. 1942

Oil on canvas
35¼ x 50¼
Museum Purchase 77.139

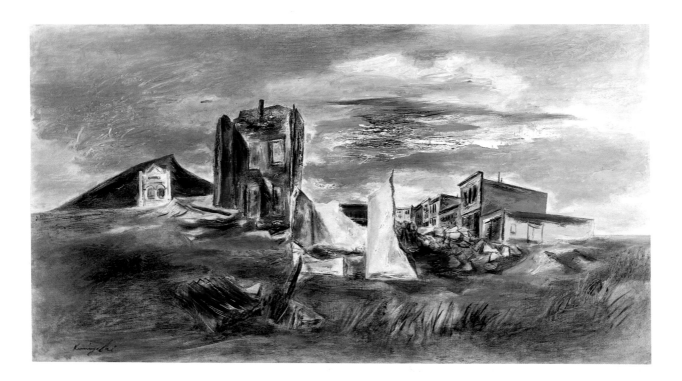

59.
Yasuo Kuniyoshi (1893–1953)
Empty Town in Desert. 1943

Oil on canvas
20 x 36¼
Edward W. Root Bequest 57.170

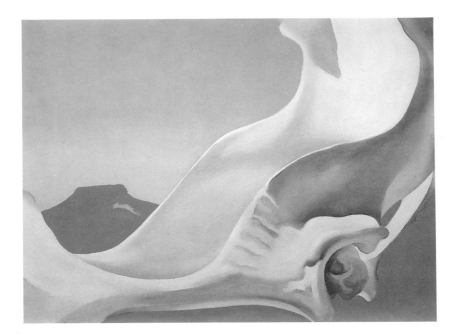

60.
Georgia O'Keeffe (1887–1986)
Pelvis with Pedernal. 1943

Oil on canvas
16 x 22
Museum Purchase 50.19

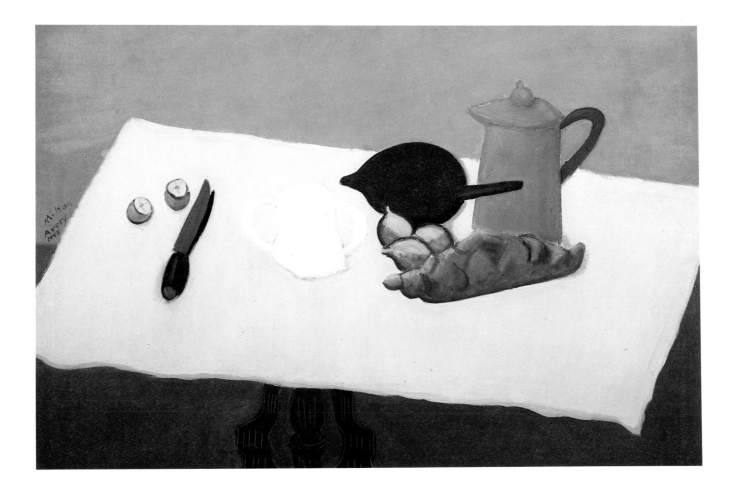

61.
Milton Avery (1893–1965)
Pink Tablecloth. 1944

Oil on canvas
32⅛ x 48⅛
Gift of Mr. and Mrs. Roy R. Neuberger 53.439

75

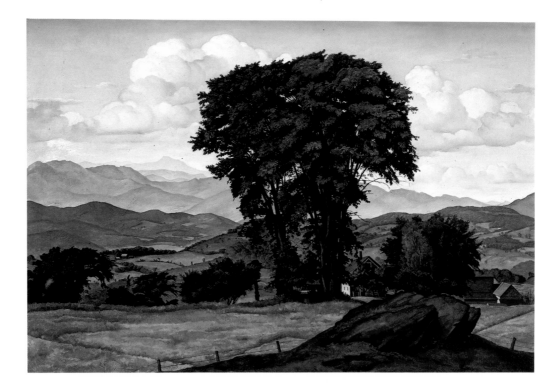

62.
Luigi Lucioni (b. 1900)
Vermont Landscape. ca. 1944

Oil on canvas
18⅛ x 26⅛
Anonymous Gift 49.32

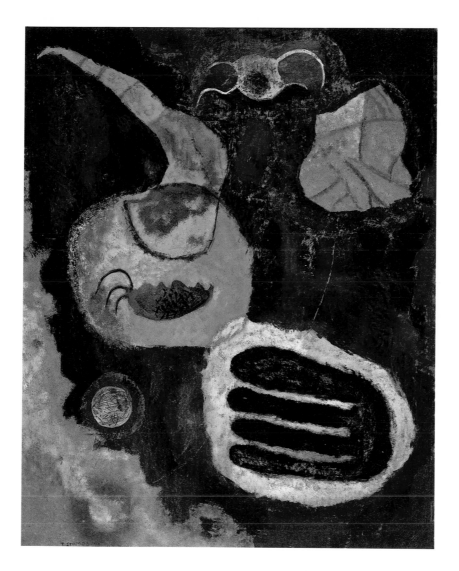

63.
Theodoros Stamos (b. 1922)
Cosmological Battle. 1945

Oil on Masonite
30 x 23⅞
Edward W. Root Bequest 57.244

64.
Mark Tobey (1890-1976)
Partitions of the City. 1945

Opaque watercolor on Masonite
30½ x 23⅞
Edward W. Root Bequest 57.264

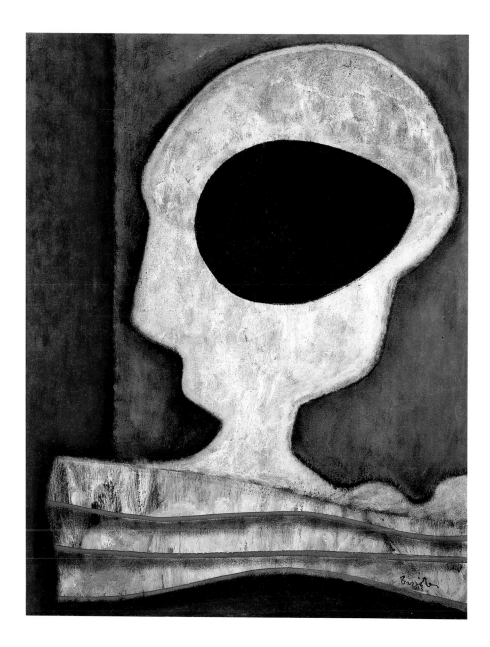

65.
William Baziotes (1912–1963)
Black on White. ca. 1946–47

Oil on canvas
36¼ x 28¼
Edward W. Root Bequest 57.69

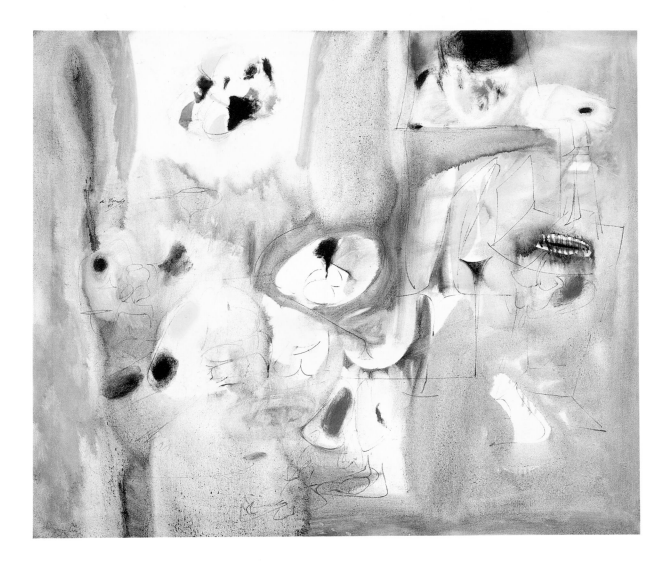

66.
Arshile Gorky (1905–1948)
Making the Calendar. 1947

Oil on canvas
34 x 41
Edward W. Root Bequest 57.153

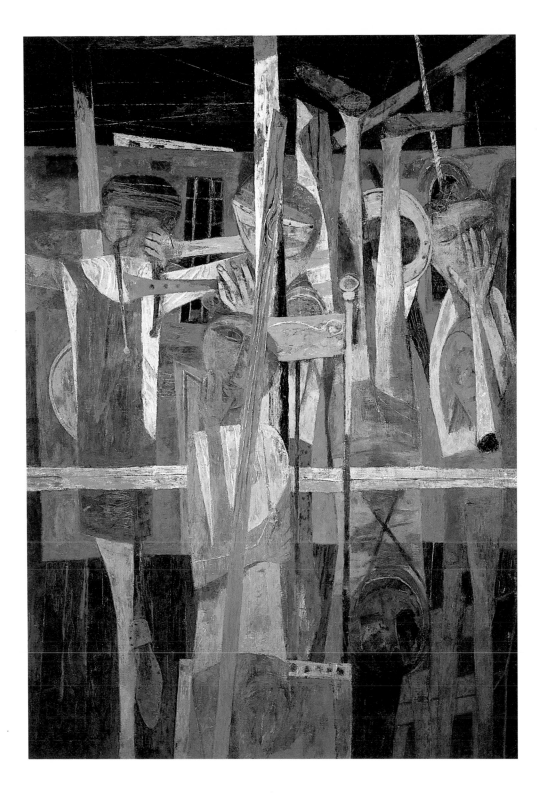

67.
Philip Guston (1913–1980)
Porch No. 2. 1947

Oil on canvas
62½ x 43
Museum Purchase 48.26

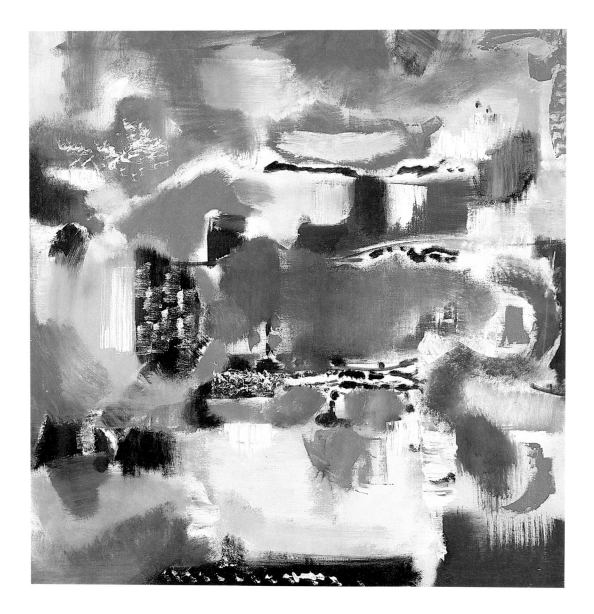

68.
Mark Rothko (1903–1970)
Untitled: Abstraction Number II. 1947

Oil on canvas
39½ x 38½
Edward W. Root Bequest 57.216

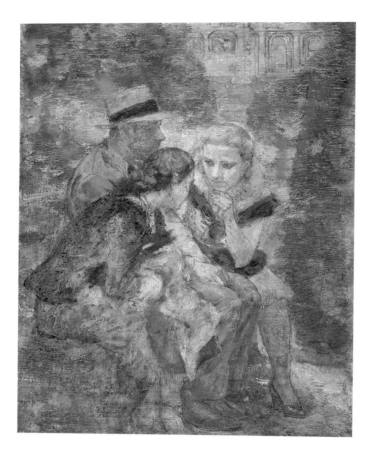

69.
Isabel Bishop (b. 1902)
Double Date Delayed. 1948

Oil on Masonite
22⅛ x 18½
Museum Purchase 50.14

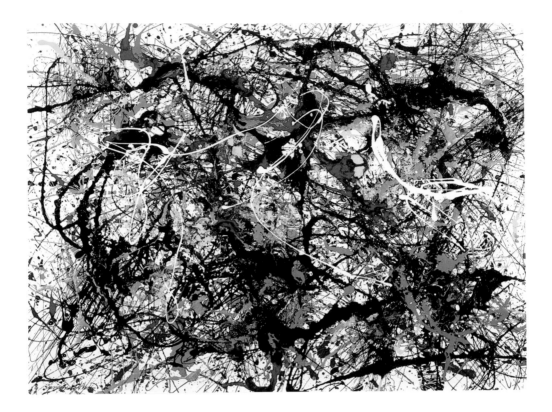

70.
Jackson Pollock (1912–1956)
No. 34. 1949

Enamel on paper on Masonite
22½ x 30⅞
Edward W. Root Bequest 57.206

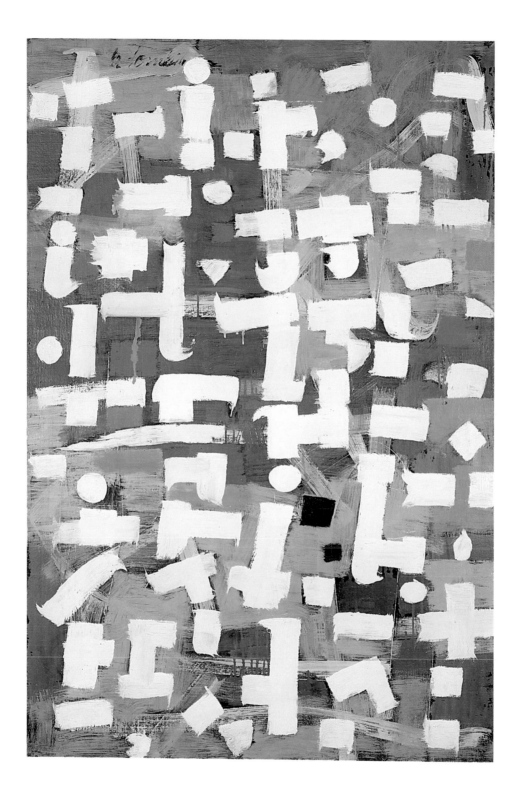

71.
Bradley Walker Tomlin (1899–1953)
No. 11. ca. 1949

Oil on canvas
44⅛ x 29
Edward W. Root Bequest 57.268

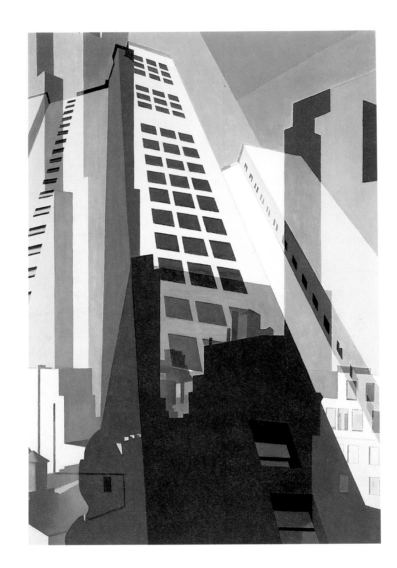

72.
Charles Sheeler (1883–1965)
New York No. 2. 1951

Oil on canvas
27 x 18⅛
Museum Purchase 51.35

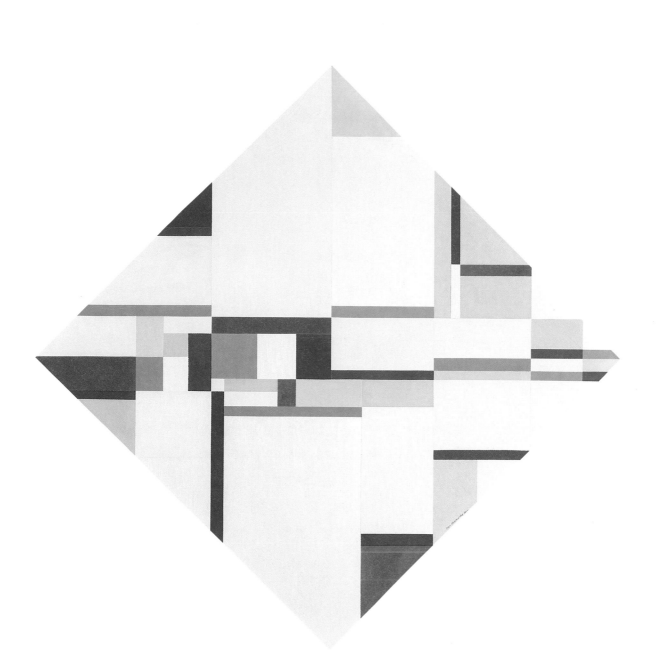

73.
Ilya Bolotowsky (1907–1981)
Diamond Shape. 1952

Oil on canvas
30 x 30
Museum Purchase 53.440

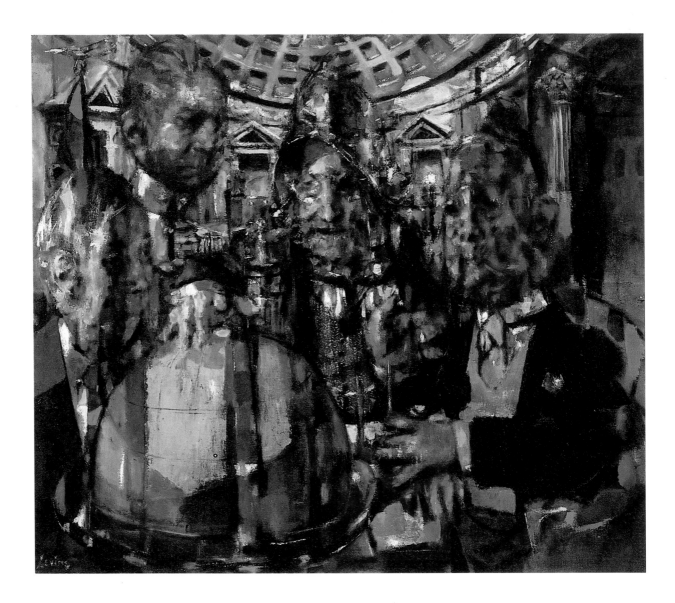

74.
Jack Levine (b. 1915)
The Golden Anatomy Lesson. 1952

Oil on canvas
42 x 48
Museum Purchase 52.16

75.
Robert Motherwell (b. 1915)
The Tomb of Captain Ahab. 1953

Oil on canvasboard
7⅞ x 10
Museum Purchase 59.14

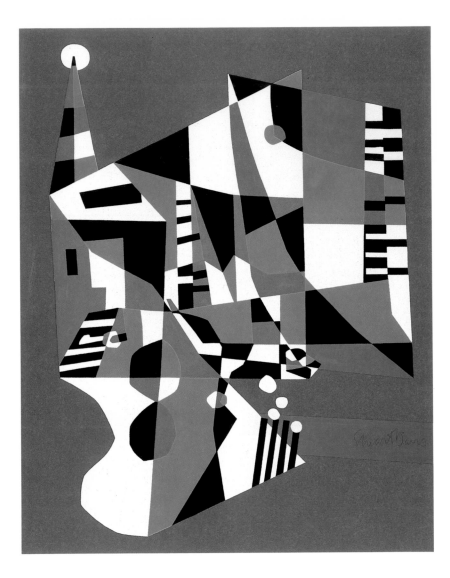

76.
Stuart Davis (1894–1964)
Tournos. 1954

Oil on canvas
35⅞ x 28
Museum Purchase 54.25

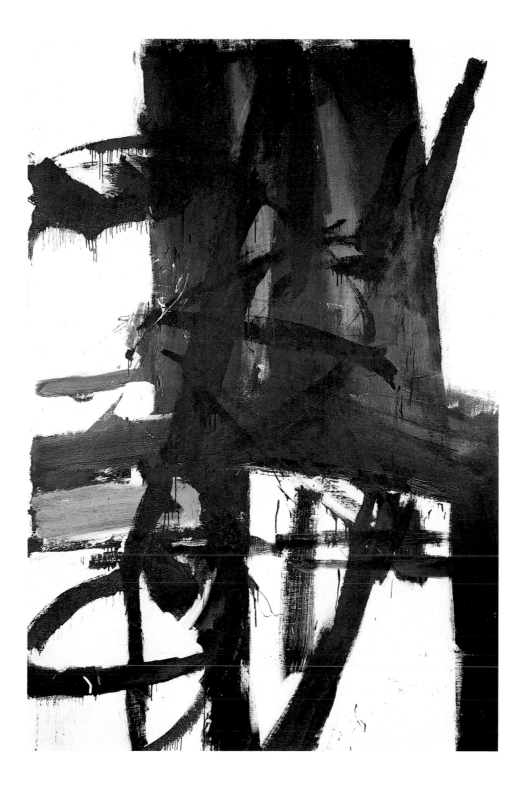

77.
Franz Kline (1910–1962)
The Bridge. ca. 1955

Oil on canvas
80 x 52¾
Museum Purchase 56.40

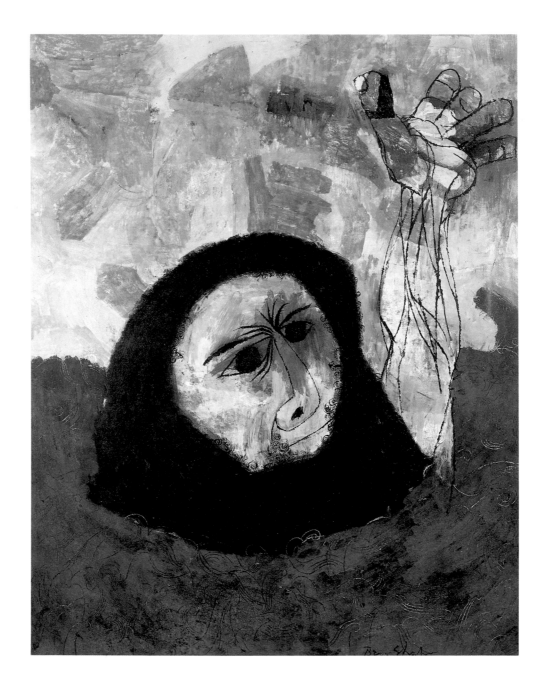

78.
Ben Shahn (1898–1969)
The Parable. 1958

Tempera on board
48 x 37¾
Museum Purchase 58.272

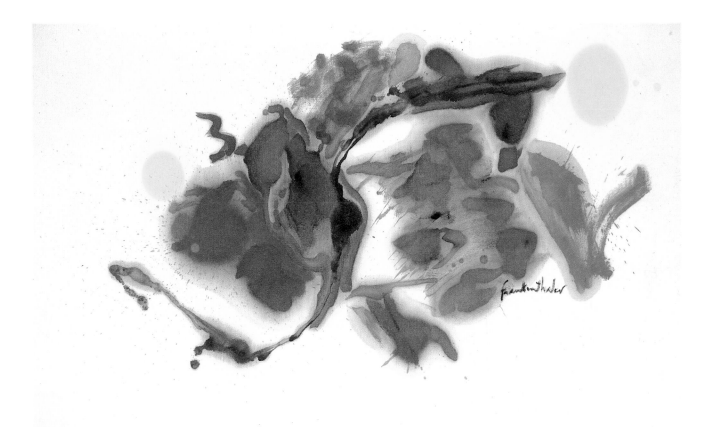

79.
Helen Frankenthaler (b. 1928)
Two Moons. 1961

Oil on canvas
32 ¼ x 52
Museum Purchase 83.24

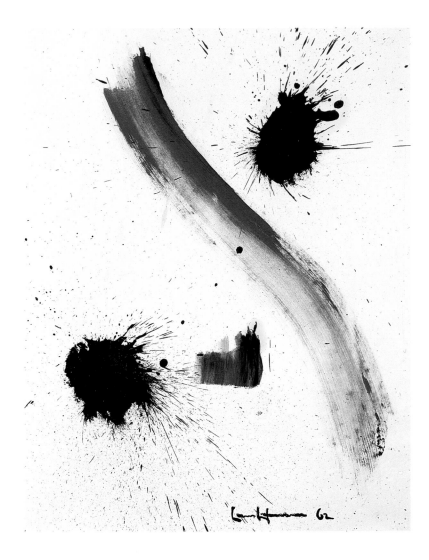

80.
Hans Hofmann (1880–1966)
Untitled. 1962

Oil on paper
24 x 18
Museum Purchase 66.17

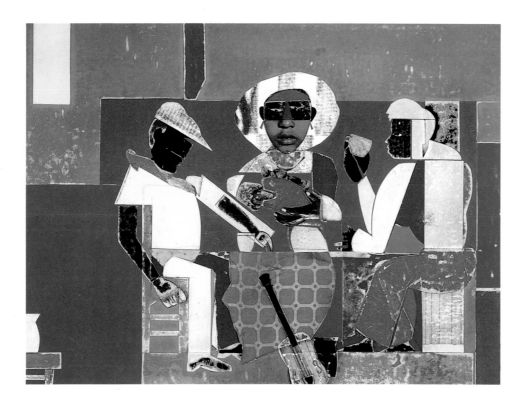

81.
Romare Bearden (b. 1914)
Before the Dark. 1971

Collage on board
18 x 23⅞
Museum Purchase 72.8

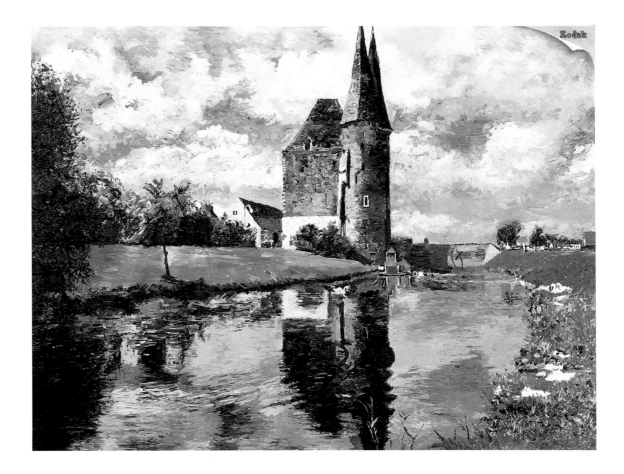

82.
Malcolm Morley (b. 1931)
Kodak. 1971

Oil on board
36 x 48
Museum Purchase 82.6

The Art Museum Association of America

Index of Artists

Reproductions of the
artists' works can be found
on the indicated pages.